CH00733130

Masterworks is about the tr crafts in northern Europe, taking as a starting point the use of timber in building. Timber frame buildings have been constructed over a long period of time over a large territory, mostly northern and north-west Europe. Various regional and local styles have come into being.

Timber buildings display a rich diversity of techniques, forms and patterns developed by generations of master craftsmen working with local materials under similar limitations. The 'arts and crafts' used in the construction of these buildings acknowledge and celebrate the knowledge, traditions, abilities and spiritual understanding of how to work effectively with natural materials. They are living traditions that remain relevant today.

Masterworks is a celebration of this arts and crafts ethos that is present in the traditional buildings of northern Europe.

Nigel Pennick is a well-known author who has written over 40 books during the last 30 years.

MASTERWORKS
The arts and crafts of traditional buildings in northern Europe

Nigel Pennick

Heart of Albion Press

Masterworks
The arts and crafts of traditional buildings in northern Europe

Nigel Pennick

Cover design: Bob Trubshaw
Cover photograph:
Guildhall, Thaxted, Essex by Nigel Pennick.

ISBN 1 872883 63 X

All text, photographs and drawings
© copyright Nigel Pennick 2002

The moral rights of the author have been asserted.

All rights reserved.

Heart of Albion Press
2 Cross Hill Close, Wymeswold
Loughborough, LE12 6UJ

albion@indigogroup.co.uk

Visit our Web site: www.hoap.co.uk

Printed in the UK by Booksprint

Contents

Note on Measurements

All measurements in this work are given in their traditional form without metric equivalents, because the national standard of the English yard and its derivatives is the relevant measure for England. It has been used since 1305 ('The Statute for Measuring Land', *33 Edward I, Stat. 6*) in the construction of English buildings and in making standard components such as tiles and bricks. It is the same with other local and national measures. The metric equivalents of English measure are as follows:

1 inch: 25.4 mm

1 foot: 304.8 mm

1 yard: 914.4 mm

Introduction

This book is about the traditions of arts and crafts in northern Europe, taking as a starting point the use of timber in building. This is a large subject, covering a large area of territory over a long period of time. Most of the surviving examples of the crafts of building in timber date from the medieval period or later. The sheer number and complexity of existing mediaeval and later structures, and the relative paucity of earlier remains, makes it a complex task to identify the origin of the various elements in the many kinds of European timber buildings, and set them in their cultural context. To identify accurately each element in the context of its time and place, and to understand how it came into being out of the specific historical matrix in which it had its being means that one can never be exhaustive or definitive. So the examples given here in this book are by way of illustration of the possibilities, rather than a documentation of every known type.

Although boundaries can never be fixed, the majority of examples I give come from northern and north-west Europe. It was in this region that the European timber frame building was developed in its various regional styles. In southern Europe, stone was the traditional material of choice for even the smallest of buildings, whilst in eastern Europe and eastern Scandinavia, log construction was favoured.

I do not intend here to infer that direct linear links exist between different styles in different places at different times, but rather I recognise that they are common solutions made by master craftsmen working in the same medium under similar limitations. To do this is to touch upon the rich diversity of techniques, forms and styles that craftsmen-builders have brought into being in Europe over a very long time, and, hopefully to help to celebrate the arts and crafts ethos that is present within them.

Nigel Campbell Pennick

Cambridge, Oak Apple Day, May 29, 2002.

Chapter 1
The Arts and Crafts of Building

Around the year 1210, in his *Poetria Nova*, Geoffrey de Vinsauf wrote: "If a man has to lay the foundations of a house, he does not set his hands to work in a hurry. It is the inner line of the heart that measures out the work in advance. The inner man works out a definite scheme of action. The hand of the imagination designs everything before the body performs the act. The pattern is first the idea, then the physical reality" (Faral 1924: 198).

The Arts and Crafts

The rubric 'arts and crafts' is used to denote the artefacts of a material culture that acknowledges, uses and celebrates its knowledge, traditions, abilities and the spiritual understanding of how to do things. The term was coined in 1888 by a group of young members of the Royal Academy in London to express the unity of so-called 'fine art' and the 'applied' and 'decorative' arts that hitherto had been seen as unconnected. To practise these arts and crafts requires a recognition of one's personal place in the continuity of culture. This necessitates being present in one's own tradition, based upon a particular place and the accumulated culture of ancestral generations.

Arts and crafts are timeless because the basic true principles of existence do not change. Things that are made that follow these essential principles are in themselves also timeless. An understanding of true principles has informed the arts and crafts of Europe through their most creative periods. This understanding has been present both in the formal, courtly arts of aristocratic and commercial patronage, as well as the everyday handicrafts of the working class.

As with everything in this transient world, human culture is ever-changing, and only manifests in the performance. Performance of any act is never the same twice, for each instance is a new event conditioned by the particular circumstances prevailing at that

1

moment. All living cultural traditions, wherever they are, must be in a state of continuous evolution, adapting themselves to the particular conditions prevailing at the moment. But the present moment is not a separate event, and those acting now are not disconnected individuals. They are part of seamless continuity, the result of those who have preceded them in that intangible phenomenon that we call the past.

Since the earliest days of civilised life, creative people have worked at their profession, producing arts and crafts that satisfied the needs and aspirations of their place and time. The natural 'laws' of physics, the given nature of the materials that we must work with, and the culturally-transmitted techniques of working with them, along with the social expectations of the moment, are engaged with by the worker, who must manage them with skill to produce the desired result. The world-view of traditional societies does not divide up the world into unrelated compartments. It appraises the connections between things and acts upon them. The essential quality of traditional culture is integration. All regional and local styles of traditional craft have developed through necessity, according to the availability of materials, the nature of landscape and climate, and cultural preferences. They are a human response to landscape, tangible manifestations of local character.

In Normandy, for example, traditional timber frame farmhouses are built with a streamlined hipped roof like an inverted ship's prow. This is at the westward end, the direction of the strongest winds. The chimney is also located at the western end, where it best draws the fire. Along the thatched roof-ridge, plants grow. In thatched buildings, the roof ridge gradually becomes the weakest point, as the thatched reed slips down the roof as the years go by, leaving gaps that can be penetrated by rainwater. So puddled clay is packed into the roof ridge, and plants that can grow under these conditions, usually the Iris and Stonecrop, are planted to bind the ridge together as a living, immovable, mass of rhizomes and roots. In the early summer, the Irises flower. The Stonecrop is held to be a magical plant, called *Joubarbe*, "the Beard of (the god) Jupiter". *Joubarbe* is seen as a protector against lightning.

Here, the physical, aesthetic and spiritual functions of a dwelling are unified. The house is warm, using the least fuel necessary because the fire burns properly. The wind does not blow the roof off, and the roof does not let in water. The inhabitants are protected both physically and spiritually. The Norman farmhouse shows us that building in harmony with the local conditions is a spiritual as well as a physical act.

In France and Germany, making timber frame building has been the business of particular families in each locality, with recognisable family styles handed on through the generations (e.g. the Schini family in the Hanau region of northern Alsace from the seventeenth century onwards; traditional social structures of pre-Christian Europe may have included craftsmen's castes, as survived in parts of Asia in later times, c.f. Kalter 1991: 8). This 'rootedness in the land' is often contrasted with the peripatetic nature of stonemasons (Guibal 1982: 51).

At first the craft apprentice has spontaneity without control. The next stage is to have control, but with the loss of spontaneity. Finally, masterhood consists of having control with spontaneity. A journeyman has served his apprenticeship and is qualified to practise the trade as an employee of a master. For this, he is entitled to the going rate of pay.

A commonly received myth is that the medieval craftsman was anonymous. Researchers including John Harvey have shown this to be false. While many are forgotten, the names of numerous individuals are recorded in many places (Harvey 1958: 64–5). Over long periods of time, inevitably there have been fluctuations in the competence of craftspeople. To variations coming from individual ability and prevailing styles must be added the vagaries of economics, climate and politics.

For any tradition to continue, the necessary skills must be handed on. At certain periods in history, the catastrophes of famine, plague and war have drastically reduced the number of skilled people. The effect of this is noticeable in English timber buildings after the Black Death of 1349, when unconventional techniques were applied, perhaps improvised by inexperienced workers who were the only ones left alive in their district (e.g. the unnecessary

pegging of joints that are stable without pegs, such as lap-dovetails; Hewett 1976: 90). The development of weapons of mass destruction in the twentieth century led to this happening on a larger scale than ever before. Coupled with industrialisation, this has proved devastating to the traditional handicrafts in the modern age.

The Use of Materials

Traditionally, there are five precepts that must be followed in making things. They express true principles at their most basic, and although ancient, they cannot be bettered. The five precepts are:

1 Suitability for purpose
2 Convenience in use
3 Proper use of materials
4 Soundness of construction
5 Subordination of decoration to the four preceding rules.

Proper use of materials and soundness of construction can be seen in all pre-industrial crafts. Traditional building does not use what Quinlan Terry calls 'new materials' that are commonly used to-day – aluminium, pre-cast and Portland cement concrete, reinforced concrete, laminated plastics, reconstituted stone, sandlime bricks and steel (Terry 1993: 129–30). When these are used in building, although they are cheaper to use in the short term, once built in, they have higher maintenance costs than buildings made with traditional materials. They also have a shorter life. Traditional building materials – timber, clay bricks and tiles, slate, sandstone, marble, limestone and lime concrete, are as near as possible inert, compared with the high thermal expansion coefficient of 'new materials'.

'New materials' expand and contract with the normal daily and seasonal fluctuations in ambient temperatures, requiring expansion joints to allow for this. These joints are built-in weak points, which, over a period of time, cause the breakdown of the structure if expensive repairs are not made. No modern building

will last as long as a stave church has. The permanence of the traditional earth-based colours is recognised by traditional builders and artists. Using colours that do not fade, but only weather in a natural way, is a powerful statement that the buildings belong to the earth at the place where they stand. By destroying the pattern-language that comes from using natural materials, 'new materials' have removed the living connection with place that is the essence of local character.

The Vernacular: Is it just a label?

One of the greatest problems of describing the past is to find a valid terminology. We can easily examine existing artefacts and classify them (when known) by age, place and form. But whether this kind of classification is truly meaningful is another matter. Because of the difficulty of classifying kinds of building, the word vernacular was considered appropriate ("our ordinary or vernacular architecture", J.L. Petit, 1861, cited by Brunskill 1987: 210–11). But the use of the word vernacular in the arts and crafts, and most particularly building, has various loaded meanings that range from anonymous to spontaneous; popular, indigenous, local and traditional, naïve, coarse and crude. Academics and art critics have thus drawn distinctions between a so-called 'architecture without architects' (the title of an influential exhibition organised by Bernard Rudofsky at the Museum of Modern Art in New York, 1963), and 'high art'. Referring to building, the word vernacular now means the everyday local forms of building as compared with formal 'monuments' or 'polite' architecture, such as palaces, churches, civic and business structures. The vernacular is seen therefore in terms of something less sophisticated, even lower class. At best, it seems 'folksy'; at worst, it has an air of inferiority about it.

Starting in the nineteenth century, classifiers of vernacular building in Britain have pieced together an agreed taxonomy that relies upon subjective criteria. This is not to criticise it, for there was and is no other way of proceeding, and what they have done is of vital importance. Yet the pinning down of any 'essence' of a style or technique is notoriously elusive. The common occurrence of

certain features within particular localities, defined largely by appearance, has been the main means of distinguishing one perceived 'pattern language' from another. Because all systems of classification begin with existing things that can be examined, the classification of vernacular structures began with surviving buildings. Clearly, it was not possible to examine buildings that were long gone. Most that exist have been built during the period when the division between educated architects and customary builders had already come into being.

The older something is, then it is a truism that the less we know about it. Unless there is documentary evidence, no one can say what were the personal experiences of a particular craftsman who made a certain building. We cannot know where he was trained, whether or not he was literate. We do not know what pattern-books he may have possessed, nor what was the degree of communication between individual craft workshops. We only have single artifacts, or groups of them, to go on. Much can be learnt from them, but conclusions drawn are often little more than best guesses.

A distinction between courtly 'high art' and 'vernacular' existed from the renaissance era onwards. But the distinction between the arts of the courtly and educated, and those of the labouring classes becomes less distinct the further back in time we take it. Perhaps the key feature in this progression was the emergence of artists and architects as professionals distinct from artisans. There emerged a division of labour between the person who designed the artefact and the person who made it. This rapidly reached the point where the designer was unable to make what he or she had designed, even disdaining the possibility. Then, another, the artisan, had to do the job. This created a class distinction between designer and worker, and downgraded the artisan from creator to functionary.

When the designer is also the artisan, then what is produced is classed as 'vernacular', which should carry no implications of inferiority. The concept of the vernacular versus the courtly is a projection back upon the past that arose in the nineteenth century. As a distinction, it cannot be sustained earlier than a certain point in history. For instance, the astonishing level of mastery in both

design and technical ability displayed by the Norse shipwrights who made the Viking vessel found buried at Gokstad makes a mockery of the received meaning of the description 'vernacular' (Nicolaysen 1882: pl. I–III). These ninth century master wrights learnt their craft in the customary way, using hand tools and traditional materials. They may even have been illiterate in the modern sense. But they were the best of their day, and their abilities were awesome.

The Gokstad ship may have belonged to a royal person, but it is clear that it was no different in principle from others built for people lower down the hierarchy. The vernacular, or traditional, is defined not by the product but by the process that makes it. The outward form of the vernacular artefact expresses the traditional means by which it has come into being. Craftsmanship as both an optimal use of materials and an outward display of skill is paramount to any structure that can be designated traditional.

When, towards the end of the nineteenth century, educated architects began using traditional forms, and even became artisans in the required skills themselves, the two parallel traditions were merged.

Tradition and Revival

Perhaps because of the encounter by Europeans of non-European cultures that had developed separately, the assumption seems to have been made by European academics at some point that local traditions in various parts of Europe were also the result of separate development. This separateness and uniqueness of individual traditions was emphasised by nineteenth century nationalists, who sought out the factors that made their compatriots' traditions different from those of other lands.

At some point in British studies of tradition, a distinction between 'traditional' and 'revival' was drawn up. According to this viewpoint, which is still prevalent in the realm of English folk music commentary, 'traditional' meant that the style, process or custom had been practised continuously since an unrecorded origin (with the implicit assumption that there was no individual authorship). 'Revival' meant that there had been a relatively

recent, and recorded, reinstatement of the practice, which, presumably, had lapsed for a period (in other areas of life, this is called 'restoration' or 'reintroduction'). This contained an unstated assumption that the 'traditional' was superior to the 'revival', having come in unbroken continuity from an unknowable origin that was somehow the pure essence of the tradition.

This distinction appears to originate in two untenable assumptions: firstly that traditional craftspeople have always received their techniques and designs directly from those who taught them, and then reproduced them in an unchanging way; and secondly that their designs have been handed on without reference to outside influences. Examination of the historical realities shows something different. Where they could not be bettered, techniques and designs remained substantially the same over long periods of time. But conservatism for its own sake was never a guiding principle. New ideas considered valuable were always adopted and incorporated into the local milieu. The historical progression of the traditional arts and crafts is testimony to this.

The state of masterhood infers that the craftsperson has reached the level of complete understanding and control of the medium and its social application. Within the structure of the craft, this means that he or she can practise and innovate. Unlike the contemporary consumer-led design business, where innovation and change for its own sake is necessary to sell products, traditional craftsmanship innovates only at the point where new techniques are deemed appropriate.

New ideas and styles were transmitted to traditional craftspeople in three basic ways. Firstly, by journeymen, who travelled to other workshops as part of their craft training, becoming aware of new things on their travels; secondly, through pattern books; and thirdly through the movement of artefacts from one place to another. Because of the perishable nature of manuscripts, and the fact that they were made for use, not to be admired in their own right, few ancient manuscript pattern books exist. The famous pattern book of Villard de Honnecourt in the Bibliothèque Nationale, Paris (made c.1220 to 1235), is a notable exception.

With the invention of movable-type printing, the production of pattern books became a viable business (Peesch 1983: 9–11).

Calligraphers and writing-masters, part of whose business had been making designs for craftspeople, were now able to spread their work widely (e.g. Schönsperger's sample books (Augsburg c.1523), *Esemplario nuovo* by Giovanni Antonio Tagliente (Venice, 1531), and the German-language *Säulenbücher* for carpenters and cabinet-makers). Some pattern books had ready-made markings to assist the craftsperson in transferring the design to the work-piece or template. Gabriel Kramer's *Schweiff-Büchlein* (1611) showed how to reduce and enlarge designs from gridded patterns.

In England in the eighteenth century, architects' and furniture-makers' pattern books had a profound influence upon 'vernacular' work. Significant works include *Six Sconces* (1744), *Six Tables* (1746) and *The New Book of Ornaments* (1752) by Matthew Locke, and Thomas Chippendale's *The Gentleman and Cabinet-Maker's Director* (1754). Over the years, by means of pattern books, certain design motifs were widely disseminated. The process continues to-day. The ignoring of these factors by early twentieth century folklorists, most of whom had experienced an elite education rather than serving a craft apprenticeship, seems to have been because they assumed that craftspeople in the past had been insular and illiterate. Recent researchers into English traditional performance have demonstrated the historic role of itinerant music-sellers in disseminating 'folk music' and the transmission of mummers' plays to literate performers through chapbooks; (e.g. Cass and Roud 2002: 102–11).

Folk art is not a static thing. Although the principles of craftsmanship remain the same, generally following the five precepts, styles have altered along the same lines as those of 'polite' art and architecture. Thus we can determine the same rough sequence of styles, beginning with the medieval 'Gothic', then the Renaissance (generally called Jacobean in Britain), Baroque (and Rococo), Neoclassical, and Neogothic. In some places, styles became fixed, and did not change when they went out of fashion in 'polite' society. Thus contemporary Bavarian woodcarvers still produce Baroque and Rococo saints alongside modernist religious images, and English canal artists still paint baroque roses.

9

During the nineteenth century, nationalist aspirations in various parts of Europe led to the re-emphasis of certain elements in the arts and crafts viewed as characteristic. In recently-unified Germany and the Austrian Empire, local traditions were promoted as *Heimatkunst* or *Provinzkunst* (home-place art and provincial art). Similarly, the so-called 'Celtic Revival' in Ireland was such an attempt to define and re-empower "the Spirit of the Nation" (Sheehy 1980: 6, *passim.*). In Scandinavia, the parallel movement has been called 'National Romanticism'.

Ancient examples became models for new versions, and a whole style emerged. In the twenty-first century, it still distinguishes nationalist and republican murals from loyalist ones in the north of Ireland. The former use Celtic motifs such as interlace patterns, Celtic crosses and images of ancient Irish heroes like Cúchulainn, while the latter have images drawn from the British Empire and the masonic Orange Order.

In late-nineteenth century Norway, the motifs from the stave churches and excavated Viking ship burials led to the emergence of the *dragestilen* (Dragon Style). This was promoted by Professor Lorentz Dietrichson (1834–1917) through two seminal books, *Den Norske Treskjærerkunst* (1878) and *Norges Stavkirker* (1892). In Finland, the movement drew inspiration from the mythological cycle of the *Kalevala*, and traditional timber buildings. In Hungary, the 1896 millennium of the Magyar settlement of Hungary was the catalyst for the promotion of the traditional arts and crafts. In all four lands, the artisans drew upon the oldest accessible examples of native architecture and folk arts. In the nineteenth century, Ireland, Hungary, Norway and Finland were all ruled by powerful neighbouring states, so the statement of a separate identity was paramount. In Germany, too, 'Germanic' elements were sought to bring a sense of national identity to the many lands which had been unified in 1871. These instances may be considered to be 'revivals', yet the artisans who worked in these styles were true craftspeople who had come up to their masterhood through traditional apprenticeships. It is undoubted that, at their best, these styles produced inspired work on a par with anything that went before (e.g. the 'Celtic' work of the Manxman Archibald Knox (1864–1933)).

Arts and Crafts Sensibilities

Because of the decline in recognised true principles in Britain over a century ago, owing to industrialisation, architects of the 'Arts and Crafts' movement sought to promote traditional skills before they were lost forever. The noted craftsman architect Mackay Hugh Baillie Scott observed, that in 'old work', we can see aesthetic rightness and beauty expressed in practical ways (Haigh 1995: 17). Following tradition, recalling the craftsman's principle of 'simplicity and singleness of purpose', Baillie Scott asserted that anything we make or do must be as perfect as circumstances permit.

However, striving for perfection does not mean attempting to efface the hand of the craftsperson, nor the denial of the innate nature of materials and 'that disorderly order which is common in nature', as Ben Jonson put it in his directions for *The Masque of Blackness*, (performed at Whitehall on Twelfth Night, 1605 (Gifford 1816: Vol. 7, 6)). Those who use traditional materials recognise that they possess their own 'life', and make artefacts that do not deny this (c.f. Hundertwasser 1991: 89, 92–3, 98). Practicality under the circumstances is paramount: chapter 34 of Mackay Hugh Baillie Scott's influential book, *Houses and Gardens*, is titled 'Making the Best of It' (Baillie Scott 1906: 134–9).

Baillie Scott and his contemporaries recognised that mass production was dehumanising, denying the workers the opportunity to use their skills and creativity to the full. This denial of human self-expression, the reduction of the potential craftsperson to a living machine, is echoed by the heartless sameness that results from mass production of buildings. The worst of them, the seemingly endless rows of prefabricated apartment blocks fashionable in the 1960s and 70s, only take on individual character by the various ways they break down, the patterns of cracks, staining and algal growth, and through the work of graffiti artists.

In traditional building, this can never happen. In any particular style, the same broad features occur, but in detailed appearance, they are never the same twice. There is repetition, but because each component has been made by hand, the craftsperson has

made that particular part for just that place in the building. So there is always variation and uniqueness in the ways that the patterns manifest themselves. 'To do well, and to have continuance in well doing' (the seventeenth century maxim of the Company of Masons at Norwich).

The Naming of Names – The Succession of 'Styles'

Art historians have identified a series of successive styles that they have shown to be dominant at certain periods of history. They are characterised by a combination of several broad features which may not all be present in any one artefact. Each of these styles has a readily-understood name, which is useful when we want to talk about it. But we must always be wary of taking the received names of things as meaningful. Names that do not come from the original craft traditions are no more than a common currency that people use to describe things to one another. These received names have entered the language by various routes, ranging from the need to have a useful general descriptor to being part of an ideological agenda. People refer to Gothic architecture, Bellarmines, hill-figures, the *dag* sign, witch posts, the Green Man, Celtic Art, and Art Deco oblivious of the fact that none of these things were called that by those who made them originally, nor by others through the greater period of subsequent history.

'Gothic' as a derogatory term for mediaeval architecture originated with Sir Henry Wotton in his *The Elements of Architecture*, (London, 1624); 'Bellarmine' from the play *The Armoury*, by William Cartwright, 1634; 'hill figures' from *The Hill-figures of England* by Sir Flinders Petrie, (London, 1926), and the *dag* sign from Walter Propping, 1935. The first use of the name 'witch post' came from the Whitby Museum in 1936, and the 'Green Man' from Lady Raglan, 1939 (Raglan 1939). The term 'Celtic Art' was popular in Ireland and Scotland in the late nineteenth century, but it was popularised worldwide by George Bain in his *Celtic Art: The Methods of Construction*, (London, 1951). 'Art Deco' was named as late as 1968 by Bevis Hillier in a book of the same name.

Similarly, signs may be given a name, such as the universal use of 'St Andrew's Cross' to refer to the X-shape even when there is no evidence that any reference to that saint was meant by the craftsman. Only by recognising the origin of our terms can we approach an understanding of the crafts of earlier days.

When something is made in a certain style, this can sometimes mean that it contains certain technical principles which are essential in making the style. Thus modernist buildings are made principally from reinforced concrete, aluminium, stainless steel, glass and plastic. Earlier styles, however, can be constructed according to vernacular methods, as attested by the baroque churches of Finland, made entirely of timber. Localised vernacular techniques may appear according to one or other of these styles without denying their traditional principles. It is this that maintains recognisable continuity in a place.

Chapter 2
Origins and Historical Development of Timber Building

Our knowledge of early timber building is limited by the perishability of the material. Archaeology has revealed a remarkable amount of information on the foundations of ancient structures, but, naturally, the upper parts have long since perished. However, there are many parallel artefacts that have survived that give some indication of the form and techniques of early structures.

Houses of the Dead and Skeuomorphism

The interrelationship of structures made by traditional craftsmen is apparent in the houses of the living and the resting-places of the dead. Because they are made to be buried, coffins are the most perishable product of the carpenter's craft. Far fewer wooden coffins have been preserved than their stone counterparts, sarcophagi.

As with all traditional crafts, coffin design varies from place to place and over time. Grave chambers made with jointed planks existed in Celtic central Europe and the structure of later stone tomb structures may have originated with the carpenters. The ancient Germanic coffins called *Totenbäume* (trees of the dead) were hewn from a single trunk of an oak tree. They appeared in the Alamannic period (213–496 CE). Some of them have lids carved with a scale-backed serpent with a head at each end. There are two in the Alamannic department of the Württembergisches Landesmuseum, Stuttgart. One hogback at Govan, Glasgow, has a very worn head at each end of the 'roof ridge', similar to the serpent on the Alamannic *Totenbäume*. This gives them some resemblance to the Viking Age stone hogbacks in the British Isles, which have been seen as houses of the dead (Collingwood

1927:167). The last recorded burial in an oak *Totenbaum* was Graf von Buchaw in 1151 (Paulsen and Schach-Dörges 1972: 21–2).

Corner-post construction was used all over northeren Europe for buildings, chests, beds, coffins and shrines. In Merovingian times, chest-like beds of the dead, made of planks fitted into corner posts, were used for burial in southern Germany as well as *Totenbäume* (Paulsen and Schach-Dörges 1972: 23–5). Similarly, in Ireland from the late seventh century onwards 'box shrines' were made from stone in the manner of timber structures (e.g. Kilnaruane and Kildrenagh; Herity 1993: 191–4). In theses, thin slabs of ornamented stone, analogous to planks, are slotted into stone corner-posts. In Poland, chests of of this corner-jointed form are known as 'sarcophagus chests' (Pokropek 1988: 72, fig. 54), used to store clothes, grain or bran. Similar chests, with hinged lids, known as *cystiau styffylog*, were in use in Wales until recent times for the storage of oatmeal, the staple diet (Owen 1991: 9–10).

The characteristic features of timber buildings are reproduced in early stone structures. In classical temple architecture, the stone triglyphs recall the end of roof timbers. Certain ancient stone churches in Ireland (post-700 CE), such as the Gallerus Oratory in County Kerry, appear to be built in the style of timber ones. Some Irish stone 'butterfly finials' on the churches at Ardwall, Freshford, Iniscealtra and Temple Macdara resemble gable ends at the crossing-point of roof beams in timber buildings. Carvings on the Viking Age hogbacks recall roof shingles (Parker 1926: 15–17, 172–7), and decorative elements in Norman (Romanesque) stone buildings clearly relate to the ornamental forms of timber structures.

Murus Gallicus

The Celts of central and western mainland Europe developed a form of defensive walling around their *oppida* (settlements or 'hill-forts'), called by the Latin *murus gallicus* (the Gaulish wall). There are two basic forms. The earlier form was made from logs jointed together in rectangular frameworks, perhaps twenty logs in height (fig. 1). Inside this stable structure, stones were packed. The outer face was rendered with masonry, and the inner side covered with

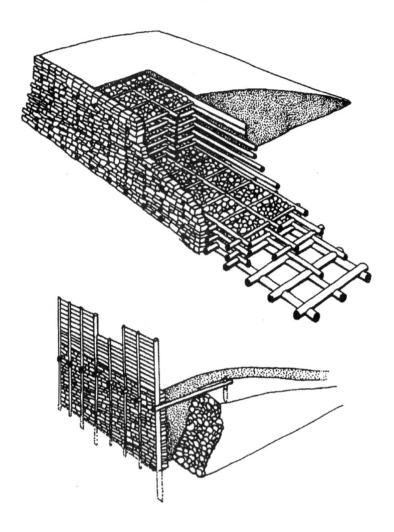

Figure 1. *Murus gallicus.*

Above: Period I *Murus gallicus* of the *oppidum* of Manching,
south Germany, second century BCE, using log-frame
construction.

Below: Simplified construction of a later period, based upon
earth-bound posts. (After Collis).

an earth bank (remains at Besançon, dated dendrochronologically as 120 BCE). The later form was simpler. It was made from vertical posts, set in the ground, between which a masonry wall was raised. These were reinforced by horizontal baulks, pegged into the rubble infill behind the wall. The posts continued above the stone wall to support an upper wooden fence which provided shelter for the defenders. There is a reconstruction of this type of *murus gallicus* at the Staffelberg in south Germany.

Crannógs

Crannógs (named from the Gaelic *crann*, a tree, mast or pole) are ancient timber constructions in a most hostile environment, for they are artificial islands in lakes. Over 200 are known to have existed in lakes in the British Isles. In general, they were made by creating a platform of brushwood, onto which stones were dropped to hold it down. Piles, usually of alder, but sometimes of birch or oak, were driven through this material, and jointed and pegged cross-beams set upon them as the foundation for timber buildings with wattle-and-daub walls (Ritchie 1942: 8–75). This principle was used for the Glastonbury lake village (e.g. Badger 1893: 242–3). The crannóg in Llangorse Lake, central Wales, was a fortified island whose timbers, excavated in 1987, gave a dendrochronological dating of 747–859 CE (Redknap 1991: 16–17). A modern replica of a Crannóg exists at Craggaunowen, County Clare, Ireland, with a wattle-and-daub walled roundhouse thatched with rushes. A larger lake-village replica, consisting of two separate platforms with buildings representing the Neolithic and La Tène periods, exists in Lake Constance as part of the *Pfahlbaumuseum* at Unteruhldingen, Germany (fig. 2).

Roman Timber Framing

Although mostly stone, brick and concrete buildings have survived from the Roman empire in the west, Roman builders also used the timber building form called *opus craticium*. In this technique, a square timber frame was infilled with a nogging of stones and

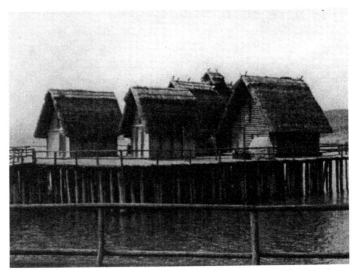

Figure 2. *Above*: Archaeological experimental reconstruction of a Celtic lake village in Lake Constance at the *Pfahlbaumuseum*, Unteruhldingen, Germany.

Below: A traditional log-built hay shed near St-Johann, Pongau, Austria.

concrete ('Its use goes back to the most ancient past' (Marta 1990: 31)). Images of timber buildings preserved in stone carvings show that Roman timber framing used frequent X-shaped cross braces, a form conserved until the present day.

Ancient Northern Halls

The lord's or king's hall features frequently in ancient sagas of the north, from *Beowulf* onwards. Some of them were substantial buildings: the sixth and seventh century great halls of Northumbrian kings at Yeavering measured about 100 feet in length (Blair 1963: 28–9, 222, 258). Construction was of square timbers mortised to the next, every second one being embedded in the earth (Wood 1983: 209). Outside were buttress posts like those found in Ezinge, Frisia, (fourth century BCE) (Horn 1958: 2–23). The ninth century hall of the kings of Wessex at Cheddar, Somerset, was a boat-shaped building, wider in the middle than at the ends, measuring 80 feet long by eighteen feet wide. It appears to have had an upper floor. When a new royal hall was built there early in the twelfth century, the carpenters still used earth-set posts in its construction (Quiney 1990: 41).

Other ancient halls appear to have had aisles. The foundations of a Frisian hall dating from the seventh century BCE excavated at Jemgum near Emden, showed it to have internal rows of posts. Norse royal halls and heathen temples were very close in structure (Turville-Petre 1964: 240–243). They may have been seen as reflecting the heavenly halls of Asgard. According to Snorri Sturluson, the Norse gods and goddesses each had their own heavenly hall. These are listed in *Grímnismál* and *Gylfagynning* as Glitnir (Forseti), Folkvang (Freyja), Fensalir (Frigg), Himinbjorg (Heimdall), Sokkvabekk (Saga), and Bilskirnir (Thor). Best known of these is that of Odin, Valhöll or Valhalla ('The Hall of the Slain'). The tenth century poems *Eiríksmál* and *Hákonurmál*, composed by royal bards in honour of the Norse kings Eirík Bloodaxe and Hákon the Good, each describe the dead king entering Odin's great hall. Some scenes on the Gotland memorial stones have been viewed as depicting warriors being received into Valhalla by the Valkyries (Davidson 1993: 33).

The great hall at Tara (Temair), seat of the High Kings of Ireland, is described in the medieval text, *The Yellow Book of Lucan*. Internally, it had a seating arrangement where the various trades, crafts and ranks of society who accompanied the king occupied their prescribed places, ranking in order of precedence. There was one door, in the end wall, which led into a vestibule where sat the doorkeepers, king's fools and champions, who distracted and warded off any unwelcome intruders. Along the centre-line of the hall were fireplaces, lights and a cauldron.

Aisled halls are also indicated in the ninth century Irish law code that contains earlier material, the *Crith Gabhlach* (Richmond 1932: 96–106). According to a medieval account, King Domnall mac Aed founded the royal settlement by the River Boyne at Dún na nGéd. As at Yeavering, and in the mythical account of Asgard, Tara consisted of a group of large halls. The *Tech Midchurata* (central hall) of Tara was surrounded by four other halls: the banquet-hall of Connacht, the Halls of Leinster and Munster and the Assembly-hall of Ulster (Rees and Rees 1961: 147). The many descriptions of these halls do not tally with one another, yet the existence of such halls in early medieval Ireland is attested by these accounts.

Anglo-Saxon and Scandinavian Temples

The heathen temples of the north were timber halls similar to those of lords and kings, as attested by the name *hof*, meaning 'hall'. Excavations have shown that heathen temples existed on the sites of the present medieval churches at Uppsala in Sweden, Maere in Norway (Lidén 1969: 23–32) and Jelling in Denmark. Timber temples probably existed in Anglo-Saxon England, such as that belonging to the Northumbrian king Edwin at Goodmanham, that was burnt by the guardian priest when he and his king became Christian (Bede, II, 13; Herbert 1994: 26). But from such meagre remains it is not possible to reconstruct the form of the buildings. The *hof* that Thorolf Mostur-skeggi 'let be raised' is described in *Erbyggja Saga* as a great house, with the door on one of the side-walls by the far end. Before the door, inside were the high-seat

pillars, with 'god-nails' driven into them. It is possible that the nails were fixings for shingles (cf. Eidsborg and Hopperstad stave churches). *Kjalnesinga Saga* tells that the images of the gods stood on a pedestal at the centre of the building. *Erbyggja Saga* was probably written at the monastery of Helgafell in the late twelfth or early thirteenth century, but Hilda Ellis Davidson deems it likely to preserve local tradition reliably (Davidson 1993: 102–3).

The temple at Uppsala in Sweden is recognised as the greatest heathen sanctuary in Scandinavia. In the eleventh century, Adam of Bremen described it 'completely adorned with gold', and to his manuscript a scholiast added a note of a golden chain running round it. This is shown in a much-reproduced woodcut of 1554 from the work of Olaus Magnus, made 450 years after the temple was destroyed. As traditional buildings, including stave churches, are made completely of wood with no metal fittings except door hinges and perhaps shingle-nails, it seems an unlikely description. It most likely refers to gilded or painted carvings on the *takfot*, the beam at the top of the wall supporting the rafters known as *bindbjalke* (tie-beam) or *stickbjalke* (interrupted tie-beam). Such carvings are known from medieval longhouses and churches in Scandinavia, including the churches at Hagbyhöga, Kumlaby and Väversunda in Sweden, which have dragons, beasts and interlaces (Sjömar 1995: 219, 222). The form of hogbacks, stone monuments of the Viking Age, recalls shingle-roofed buildings with the richly-carved *takfot* beneath (e.g. Lang 1994: 123–131, figs. 56, 58–60; Stone 1999: 16–20).

The actual detailed design of these heathen temples is a matter of contention. Excavations at Uppsala and Jelling have shown that large timber buildings preceded the extant medieval churches, but whether these were earlier timber churches or temples is unknown. Perhaps some of these temples were converted into churches, as recommended by Pope Gregory in his famous letter to Abbot Mellitus. It has been suggested that Anglo-Saxon house shrines of Christian provenance may have been miniature copies of the *hof* (Chaney 1970: 75).

Slavonic Temples

Temples of the West Slavonic gods in what is now Germany and Poland were significant timber buildings. Their design was developed locally in the early medieval period from house and fortress building techniques. They existed into a period from which contemporary accounts survive (Thietmar, Einhard, Bruno von Querfurt, Adam of Bremen, Helmold, Saxo, Ebbo, Herbord, texts of the monks of Priesling, the *Knytlingasaga*, and the *Chronicle of Richard*). The name for a temple was *continen*, from the Polish *konczyna*, an 'end' or 'gable', for temples were buildings with gables (Herbord, II, 31). The name given to them indicates that the architectural form of the *continen* distinguished it from other buildings. That at Gozgaugia was described by Herbord as 'a temple of wonderful size and beauty' (Herbord, III, 7), while the main *continen* at Sczeczin that contained the three-headed image of the god Triglaus (Triglav) was 'rich in ornament and art', having painted sculptures on the wall, images of people, birds and animals 'so natural that one could take them for living and breathing beings' (Herbord, II, 32).

The temple of Svantovit at Arkona on the holy island of Rügen had an earth floor, into which the legs of the god's image were set. The temple had a single entrance, and the roof was supported by four columns (Vána 1992: 90–91). A good idea of the form of construction of Slavonic temples has been gained from archaeology. The buildings appear to have been made from vertical timbers, roofed with shingles (fig. 3). Oaken staves with representations of human faces were excavated from the ninth century remains of the Wendish temple of Ralswieck-Scharstorf on the isle of Rügen (Vána 1992: 171, fig. 39). Humanoid knobs also existed at the top of the vertical planks forming the walls of the Slavonic temple at Gross-Radern (Vána 1992: 169, fig. 37). Fences around sacred enclosures probably had the same form, such as those from the holy grove near Stargard (Szczecinski), sacred to the god Prove. These shrines and temples were destroyed by German and Danish crusaders in the eleventh and twelfth centuries (e.g. Retra, 1068; the Pomeranian temples, 1124–28; Brandenburg, 1136; the Rügen temples, 1168).

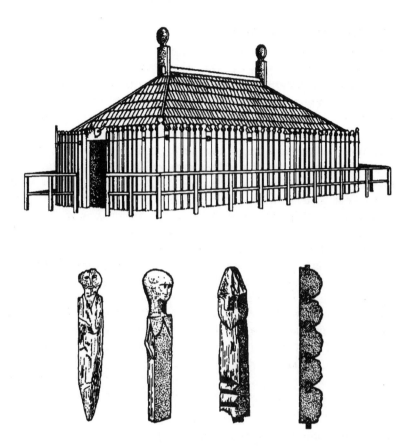

Figure 3. Sacred Staves and Stave-Buildings.

Above: Reconstruction, after Schuldt, of the ninth century CE
Slavonic temple of Gross-Radern, Mecklenburg, Germany, with
anthropomorphic stave walls.

Below, left to right:

Anthropomorphic stave from the temple at Ralswiek-
Scharstorf, Rügen, ninth century;
Stave figure from Oberdorla, third to fourth century CE;
Stave from Staraja Rusa, Russia, eleventh century;
Plan of stave-wall construction of the Anglo-Saxon church at
Greensted, Essex, tenth to eleventh century.

Norwegian Stave Churches

Norwegian church-building in timber has its own specific character, exemplified by the stave churches. Bugge and Mezzanote estimated that from the eleventh to the thirteenth century, around a thousand stave churches were built in Norway (Bugge and Mezzanote, 1994: 9). Although many were destroyed to accommodate larger congregations, twenty-eight still exist. The identifying characteristic of the stave church is the means of support of the centre of the building, which is in the form of a tower. This is an enduringly stable structure based upon four masts that rise from a double-square ground frame. This is suggestive of shipbuilding technique (Dietrichson and Munthe 1893: 35). The upper parts of the masts are connected together by cross-beams braced with X-beams and arch segments. There are two variant ways that the masts are fixed to the ground frame. In one they are mortised into the lapped crossing-point of a flat frame, and in the other, the masts are slotted and fit over the joints of an upright frame (Dietrichson and Munthe 1893: 20–21). This latter method was used also to hold the main post or *standaard* of post mills in western Europe (Notebaart 1972: figs. 84, 85); (e.g. the North Mill at Hondschote, near Dunkirk (Devliegher 1980: 196)). Post mills originated in Normandy, the part of France conquered by Norwegians, and it is possible that they are part of the same carpentry tradition as stave churches.

Spire construction in churches in England (Hewett 1969: 17, 35) and Scandinavia continued the stave principle until the nineteenth century. The base of such church spires is formed of a timber frame that supports usually eight or twelve spars (called *gratsperrer* in Norwegian). At the centre of the spire is the *midtmast* (centre mast, the English 'spire mast') (Rønningen 1990: 258 fig. 3). This provides the main support, as in the stave churches, though the frame is supported by the church walls, not a foundation in the earth.

Although fantastic artists' impressions of the heathen temples often show them in the form of masted stave buildings, earlier churches and perhaps temples at stave church sites appear not to have had the stave church form of construction with masts supported by a ground frame. Remains and post-holes excavated at

Norwich (Ayers 1985), are similar to the findings of excavations beneath the stave church at Urnes in Norway, which appears to have been an earlier church with posts embedded directly in the earth. Because of the transportability of timber frame buildings, several have been moved over the years. Two were exported from Norway. In the nineteenth century, the church from Wang was taken to the Sudeten Mountains region (now Poland) and re-erected at Karpacz (Gielzynski, Kostrowicki and Kostrowicki 1994: 133, fig. 139). It is erroneously referred to as the 'Wang Temple'. Another Norwegian stave church was taken to Hedared in Sweden. Those from Holtålen and Gol were dismantled and re-erected at open-air museums at Trøndelag and Borgund respectively (Valebrokk and Thiis-Evensen 1994: 75, 89). The church at Fantoft, which had been transported there from Fortun in 1884, was destroyed by arson in 1992 (the perpetrators were the so-called 'Satanic Terrorists', who burnt nine churches in Norway in 1992–3 (anon. 2000: 22)). A new copy of the church was erected subsequently on the site by the church's guardians, the Kjøde family. The Urnes church was added by UNESCO to its World Heritage List in 1980.

The Progress of Timber Frame Construction

Before the twelfth century, evidence of the exact forms of timber framing is scarce. In England, there are no timber frame buildings extant from an earlier period. At Cheddar, the excavations of the successive royal halls provides an instance of change that may indicate increasing sophistication. In the twelfth century, earth-set posts were used for a new hall there but, when it was rebuilt around 1210, the posts were set upon footstones, inferring the use of newer techniques (Rahtz 1979: 170–85). These methods may have been brought to England from mainland Europe, for timber frame buildings with sills, and aisled buildings with posts set on stones were being built in Germany (e.g. in the *Kaufleuteviertel* (merchants' quarter) at Lübeck, from 1160 onwards) (Fehring 1996: 145–160).

Full-scale timber-frame structures of a type that became the norm were being built in mainland Europe in the twelfth century. This was the heyday of stave church construction in Norway, and the building of large timber roofs on stone buildings. During the 1300s, standard joints came into being in England that were conserved by carpenters in England and Wales until the decline of timber building in the nineteenth century. In Germany, too, standard forms emerged in the 1300s, and by the 1400s, the typical forms of framing were in existence.

Storehouses and Market Halls

Across the north, from the British Isles to western Siberia, traditional granaries and storehouses for provisions are small wooden buildings raised above the ground on posts, stones or pillars. In England, mushroom-shaped 'staddle stones' which supported long-vanished granaries are sometimes used as garden ornaments (timber frame granaries on staddle stones existed mainly in the south of England, and the Welsh borders) (Lake 1989: 25). A basic form from central Norway and Sweden is the South Saami storehouse of the *Najaala* type, a log building on poles, accessed by ladder (Pareli 1984: 116). In structure, these are closely related to the traditional wooden above-ground burial chambers of some Siberian peoples (Nioradze 1925: 9, 15).

As safe storage of food is a matter of life and death, customarily storehouses are the focus of particular rites and ceremonies that serve to protect them. In places where the worship of the old gods continued into modern times, sacred images are kept in granaries. In Estonia, for example, images of the gods Tönn, Metsik and Peko are kept traditionally in storehouses that stand raised off the ground on stones (information from the Eesti Rahva Muuseum). The spirit-sheds of the Ob-Ugrian people in Siberia (Kodolányi 1968: 103–106), which contain sacred objects, are wooden structures raised off the ground by six vermin-repellent wooden pillars in the manner of storehouses. The earliest windmills, too, were raised off the ground, raising the possibility that they were derived from raised granaries containing hand-mills.

Several notable surviving timber frame market halls in south Britain are raised on pillars as protection for the wares stored within. The guildhall at Thaxted in Essex (fig. 4) and the market hall at Ledbury in Herefordshire are good examples of two different types. The Thaxted hall is a short-post structure with two jettied storeys supported on arcaded timber pillars with dragon posts at the corners. The supporting posts are jointed into a sill that stands on a brick foundation. That at Ledbury has pillars supporting what is in effect a long-post structure, a one-storey hall, with each post standing directly on a stone base rising from a stone plinth. At Llanidloes, mid-Wales, the Old Market Hall, similar in structure to that at Ledbury, stands at the intersection of the town's four main streets, with visibility beneath the building along their length. Its location is the classic place of the market cross. (This follows ancient Roman town layout at the crossing of the *cardo* and *decumanus*, the north-south and east-west streets, derived ultimately from the Etruscan Discipline). The Llanidloes market hall is a timber frame building with added stone walls at each end. In Wymondham, Norfolk is another kind, built according to the same principles as Ledbury and Llanidloes, but octagonal in form.

Windmills

Vertical windmills, that is, mills with sails that turn in the vertical plane, appear to have been invented in northern France during the twelfth century (Notebaart 1972: 96). The earliest mills were post mills, timber frame buildings pivoted upon an upright post held steady by an X-shaped ground frame. The entire building (sometimes called the 'buck'), is supported at a single point by a horizontal beam called the crowntree, upon which it can be turned to face the wind. The form of windmills may have originated with granaries and storehouses, which are traditionally raised off the ground on posts. The sails are supported by the windshaft, which transmits its energy to the millstones through gearing. To withstand the stresses of operation, windmills must have a very robust construction. Timber is the ideal material, for its flexibility allows the transmission of stress without breaking the joints.

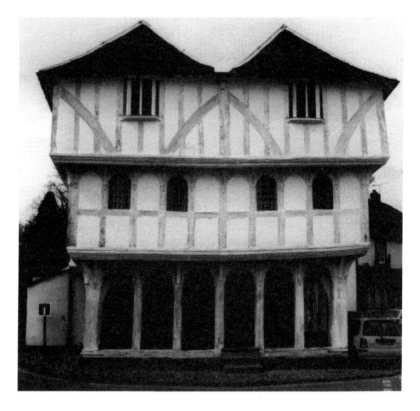

Figure 4. Jettied guildhall on timber pillars, Thaxted, Essex.

Both in their placement and use, windmills show a subtle understanding of natural conditions. Each mill was built specifically for the place where it stood. Millwrights built their mills to work under the given conditions of the place, designing specific features to enable the miller to make the best use of the wind at all times. In the Netherlands, where the craft of windmills reached its greatest development, some mills bear indicators of wind-speed and direction. They are not the gauges of industrial instrumentation, with numbers to indicate speed, but from the non-literary tradition of direct experience. Certain structures enable millers to judge precisely the conditions without needing to look at instruments. I was told by a Dutch mill-keeper that

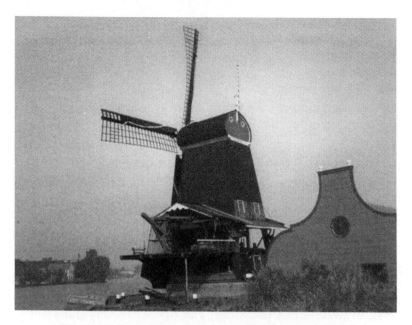

Figure 5. *Paltrockmolen* (saw mill) *De Gekroonde Poelenburg*, reconstructed 1869, at the Zaanse Schans, Zaandam, Netherlands, showing the *makelaar* on the windmill's rear gable.

experienced millers can determine changes in wind direction by the change in the sound that the wind makes through certain apertures in the mill sides.

Also, the gable ends of *wipmolen, paltrokmolen* (fig. 5), and some post mills have a hipknob called the *makelaar* at the opposite end of the roof from the sails. This is a carved and sometimes painted post with apertures that make a whistling sound in the wind. The miller can estimate the wind speed by the sound from the *makelaar.* The medieval 'whistling weathercocks' of western England (Mockridge and Mockridge 1990: 35, 57) are similar in function. The working buildings of Dutch industrial mills have a small vane with rotating blades, called a *spinmolen* or *spinnertje.* Bearing an image of the mill's name (such as a cat for *De Kat*), the speed of rotation of the 'spider mill' or whirligig denotes both wind speed and direction.

Dangerous winds between 7 and 9 on the Beaufort Scale have their own names. Winds of strength 7–8 (55–68 mph) are known as *Blote bienen*. All canvas is removed from the sails at this force. Strength 8–9 is called *Blote bienen en geknipte nagels* ('bloody bees and clipped nails'), and special braking canvas is unfurled on the sails to slow them down, for runaway sails run the risk of fire through friction, the bane of windmills.

Fantails are a feature of English tower mills. The fantail is linked by a drive shaft and gearing to the rim of the cap. When the wind changes direction, the vanes of the fantail rotate, driving the gearing and turning the cap to face the wind. The system is automatic and continuous, requiring no human intervention.

Mills are a repository of magical lore and folk tradition. Traditionally, they are seen almost as living entities, with their own personality. All mills in the Netherlands and Flanders are named (Huys 1993: 6ff). In East Flanders, names vary from those of the owner, the locality, epithets and 'fantasy names' (Huys 1993: 6). Names like The Swan, The Goose, The Fly and The Cat appear along with The Drunkard and The Dragon from Hell. Perhaps through Dutch influence, Cambridgeshire millers called their windmills by such names as Black Bess, Bullrush, Hooded Maria and Lucy (Porter 1969: 395). Most English windmills are called by the name of their locality, or their owner.

Ceremonial Fenced Enclosures

In northern Europe, there is an ancient tradition of fencing off special places. Early Christian legislation against heathen practices in Norway and Sweden forbade people from worshipping at groves, stones, in sanctuaries and at *Stafgarðr*, 'fenced enclosures' (Olsen 1966: 280). These northern sanctuaries were surrounded by a *vébond*, a fence made of posts connected by a rope. Helmold's twelfth century *Chronicle* records that the holy grove of the god Prove at Stargard (Szczecinski), Pomerania, was enclosed by a fence (Vána 1992: 178, fig. 44). Perhaps the Polish practice of fencing roadside crosses is a continuation of this practice. The custom of fencing off pieces of non-ecclesiastical holy ground in much more recent times is recalled in the Scots tradition of the

Gudeman's Croft (otherwise called the Halyman's Rig, the Black Faulie or Cloutie's Croft) (McNeill 1957: I, 62). This is a piece of land which neither spade nor plough is permitted to touch. It is commonly the triangular corner of a field, fenced and dedicated by the farmer with a promise never to till the earth there.

In the north, places where ceremonial combat took place were similarly fenced. The Icelandic settlers of the Viking age had a strict set of rules for the formal conduct of trial by combat called *hólmganga* ('going on an island'; a fight on Leidarholm, Iceland, is described in *Cormacs Saga*, X). This was fought, if possible, on a small island. Island or not, a *hoslur* ('the enhazelled field') was laid out at a convenient place. The *hoslur* was the forerunner of the modern boxing ring, the combatants fighting upon a 'cloak', which was a piece of fabric or skin five ells (about 50 inches) long. At the corners were loops, through which were driven 'certain pins with heads to them, called *tjösnur*', using a ritual known as 'The Sacrifice of the *Tjösnur*' (Collingwood and Stefánsson 1902: 67). Round the cloak, three squares were drawn, each a foot in width. Hazel poles were hammered into the earth at the four corners.

The enhazelled field was a symbolic inversion of the *vébond*. Customary law forbade anyone to take a weapon beyond the *vébond* into a holy enclosure. The *hoslur* reversed this, enclosing the weapons and fighters within the limits of the boundary. Similarly, in medieval England, tournaments and trial by combat were conducted within the 'lists'. These were wooden fences that demarcated the area where fighting was allowed. A sixteenth century text describes them as, 'low rails or pales of wood, painted with red' (Ferne 1586: 324).

In addition to fences, public performances such as tournaments, pageants and executions also required the construction of temporary 'scaffolds' or stands for the spectators. These were invariably made from timber. An account of a trial by combat, held in 1571 tells how it was 'one plot of ground one and twenty yards square, double-railed for the combat... a stage being set up for the judges. ... all the compass without the lists, was set with scaffolds one above another, for people to stand and behold'(Grose 1775: I, 181–183).

The Globe and Other Theatres

In his prologue to *King Henry V*, (c.1599), William Shakespeare called his famous theatre 'this wooden "O"' but of course the essentially rectilinear nature of timber framing meant that the Globe, and the other theatres and bear- and bull-baiting arenas were necessarily polygonal in form. The Globe was not the first of these structures in the purlieus of London. It was preceded by the Red Lion (1567), the Theatre (1576), the Curtain (1577), the Rose (1587, extended 1592) and the Swan (1595). Some of the symbolic geometric and numerical elements in these theatres are discussed in *The Byrom Collection*, by Joy Hancox (Hancox 1992: 95–128). The spectators' scaffolds for events like the 1571 trial by combat were being made by carpenters at the same time that the London theatres of Burbage, Henslow and Shakespeare were erected. The theatres clearly appear as permanent and grander versions of these temporary structures.

The Globe, which stood from 1599 until 1613 when it burnt down, is famed as the place where many of Shakespeare's plays saw their first performances. The Globe was designed by master carpenter Peter Streete, who also built the Fortune (Streete's contract for the Fortune theatre, January 8, 1599 old style (1600 in the Gregorian Calendar), is reproduced in Mulryne and Shewring 1997: 180–182). Like the temporary scaffolds, construction of these buildings was rapid. For instance, the Fortune theatre contract was signed in January and the first performances appear to have been staged the following November or December (Mulryne and Shewring 1997: 180).

To create the present Globe Theatre, which was erected in the 1990s but not on the original site (which has not been preserved) (Leech 1997: 36–37), various investigations were made of the site of the original theatre, and possible timber framing forms. Finally, the architects of the new Globe took their techniques from researches made on old work at the Weald and Downland Museum and extant timber frame buildings in southern England, though John Greenfield mentions the continuing timber framing guilds of France and Germany as 'small and highly secretive' (Greenfield 1997: 104). This is a misunderstanding of tradition, for the French and German (and Polish) masters are professionals

who make a living from the craft of building in timber. Of course, as guildsmen, their inner knowledge is not given to those who have not served as apprentice and journeyman, but this is different from being 'highly secretive'. It is the traditional way. A French or German master would have relished the challenge, and been able to use his knowledge, handed on as an unbroken chain since medieval times, to create the difficult joints needed at the Globe. As it was, methods were devised that had no direct precedent. However, the present building does give a wonderful impression of what Streete's building may have been like, and those who brought the project into being deserve praise for their perseverance in the face of considerable difficulties.

Timber, Thatch and Fire

The original Globe theatre was burnt down on June 29, 1613. During a performance of Shakespeare's *King Henry VIII*, a cannon fired on stage accidentally ignited the thatched roof, and the whole building was consumed in less than two hours (Mulryne and Shewring 1997: 187). Towns and cities constructed largely of timber and thatch have always been susceptible to fire, as the result both of war and accident. In addition to individual building fires, it was common for fires to ravage whole districts. Cambridge was destroyed by fire by the marauding Danish army in the year 1010; Chester was burnt twice in the twelfth century by accident. Between the years 961 and 1265, there were eight widespread fires in the city of London alone. The fire of July 10, 1212 left around 3,000 dead (Home 1927: 103), and after this disaster, the London Assize ordered that anyone who wished to build, should take care that he should not make his roof with reed, rush, straw or stubble, but only with tiles, shingles, boards, lead or plastered straw. After a serious fire, Norwich made tiled roofs compulsory in 1509 (Nash 1991: 16).

Several major fire disasters occurred in English towns in the seventeenth century, including the burning of Wymondham in 1615, the torching of Beaminster by royalist forces in the English Civil War, another devastating accidental fire at Northampton in 1675, and 'The Great Fire of Warwick' in 1694. Most catastrophic

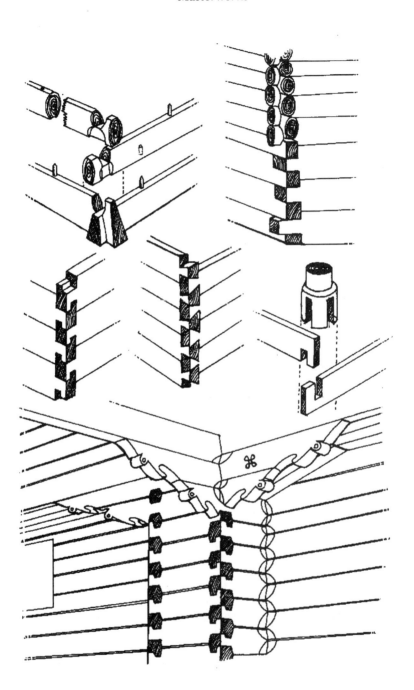

of all was the Great Fire of London in 1666. Although accidental, a French watchmaker, Robert Hubert, who also happened to be a Roman Catholic, confessed to starting the fire, after which he was executed (Smith 1861: 417–418). Recurrent fire disasters in many places led to the imposition of building regulations to reduce the risk. After the 1666 London fire, all new buildings in the city had to be constructed from brick or stone. The 1774 London Building Act banned exposed timbers, though occasionally the regulations were flouted (West no date: 45).

Advanced Timber Construction

Under the influence of Baroque sacred geometry, timber building craftsmen in eastern Europe and Scandinavia applied their craft to create quite remarkable churches. A spired pentagonal church at Griebenow, Pomerania, dating from 1650 was made by the master Gerd Antoni von Keffenbrinck (Hinz 1996: 130). In 1676, Martin Snopek, member of the guild of bricklayers and carpenters of Gliwice, Poland, designed a timber chapel at the church of St Ann in Olésno, Poland (Pokropek 1984: 16). This had a hexagonal dome. Octagonal and Y-shaped timber churches of log construction appeared in Norway in the seventeenth century (Christie 1991). Complex domed work was constructed by timber architects in eighteenth century Finland. The most notable are at Kuortani, by Antti Hakola, 1777; Ruovesi, by Matti Åkerblom, 1777–8, and Ylihärmä (fig. 6) by Kaapo Hakola, 1785–7 (Petterson 1978).

Figure 6. Log and plank construction,
Scandinavia and eastern Europe.
Top left: Ground frame and first log, Telemark, Norway.
Top right: Church at Syrin, Poland, 1305.
Second row, left and centre: Traditional Romanian planking
corner-joints (*coada de rîndunica*).
Second row, right: Jointing of a mast base in some
Norwegian stave churches.
Below: Sophisticated plank carpentry in the church at
Vöyrin, Finland. After Eero Petttersson. The sign called
Hannunvaakuna or *Sankt Hans Vapen* appears in its
traditional position.

The carpenters who made Russian timber churches also developed sophisticated architectural forms. From the seventeenth century onward, new churches were virtuoso displays of carpentry. Quite remarkable churches exist in remote areas. Some have low spires known as 'tent roofs', generally octagonal and also shingled. Others have the famous 'onion domes' covered with wooden shingles. The difference in styles in the Russian north comes from a decision in the mid-seventeenth century by Patriarch Nikon to ban 'tent roof' churches, and insist on ones with domes (Fiodorov 1976: 16). So more complex carpentry and shingling had to be developed to accommodate the new style.

Temporary Huts, Lodges and Shelters

In parallel with highly sophisticated buildings made by the best craftsmen, there have always been the houses of the poor and, at an even more basic level than them, temporary sheds and huts. However basic they may be, these have specific forms. They are made all over Europe, wherever men and women have worked away from home in the woods or the fens: fishermen, shepherds, woodmen, charcoal burners and bodgers (wood turners using a pole lathe). The Fenman's Lodge, used in Cambridgeshire, is made from willow poles (Barrett and Garrod 1976: 4–5). Two are bent to make arches, and others are lashed to them by strips of willow bark. It is covered by a rough thatch of reeds, and has a door attached by hinges made of dried rabbit skin. Another East Anglian temporary building is the Shrough Shed, made in the days when livestock was kept in the open fields throughout the year (shrough is an East Anglian word meaning 'fragments of sticks... any sort of refuse or sweepings' (Forby 1830: II, 299)). These makeshift buildings consisted of roughly-hewn timbers hammered into the ground for corner-posts, to which were tied or nailed poles to support the roof. The walls were made from available sticks, tied first using bramble, hazel or willow withies, into bundles approximately a foot in diameter and seven feet high. The roof was made of hedge cuttings (Dixon 1981: 36).

In early twentieth century Essex, the charcoal burners' huts of Epping Forest were about twelve feet in diameter, made from twelve saplings arranged in a circle, with room left for a door.

They leant inwards, and were tied together near the top. The structure was made watertight by a covering of sods of earth, with the grass side inwards, overlapping like roof shingles (Warren 1909: 65–72). These huts were of a similar form to those built in Scandinavia by the Saami (Pareli 1984: 111–24), temporary summer buildings in Estonia (Buschan 1926, 985, fig. 625), and by woodsmen in France (Chevalier and Raffignon 1941: 30) and northern Hungary (Peterszák 1989: 325–36, fig. 11).

Something like these temporary shelters were made by the poor who took advantage of an ancient customary law, the construction of a 'one night house' on the enclosed roadside wasteland. The custom continued into the early twentieth century in north Bedfordshire and Huntingdonshire (Tebbutt 1984: 49). In Wales, this is called the *ty unnos* (Owen 1991: 26, 61). Built of necessity in a hurry, so long as the ground was fenced, and smoke was coming from the chimney by dawn, then the place became the legal property of the builder (though landowners often saw to it that their men destroyed the squatter's crops at the most damaging time (Owen 1991: 62). A replica *ty unnos* can be seen at the Welsh Folk Museum, St Fagan's. Later, if the squatter was not driven off the land by the landowner, a more substantial building would replace the one night house. There was a house near St Ives, Huntingdonshire, called Republic Cottage, that was said to be on 'no man's land', having replaced a 'one night house'.

Building With Living Trees

Carpentry is the art of working with timber, and this has not always meant dead timber. There are traditions of houses built incorporating living trees, or upon living trees. A tale I was told of the Cross Keys Inn in Saffron Walden alleges that it was originally built around a living tree. A recreation of Hunding's timber house, first designed for a stage set for the first act of Wagner's opera, *Die Walküre* (based on the *Nibelungenlied*), was constructed for King Ludwig II of Bavaria at Schloss Linderhof in 1876. Designed by Christian Jank, it was a timber-plank building which had a real tree as the centre-post, as in the old Germanic legend (Hojer 1986: 37). Subsequently, in 1945, it was burnt by American soldiers and later reconstructed without the tree through the roof.

In both western England and Germany, at one time it was customary to erect platforms amid the branches of large trees on which people would feast and dance. There is little information about this practice before the eighteenth century. What seem to be demons dancing on a trained tree appear in the background of Peter Breugel's sixteenth century apocalyptic painting *Dulle Griet* ('Mad Meg', c. 1562).

In 1709, the French master gardener Antoine-Joseph Dezallier D'Argenville wrote, 'There are trees in Germany that have been pruned in a particularly ingenious manner: their pruners have made proper rooms from them... the crown forms the roof, as well as the walls. The flooring of them is made from boards laid onto wooden posts or stone pillars' (D'Argenville 1709: 96). Platforms existed on certain German 'town' or 'village linden' trees (*Dorflinde*), such as at Altötting, Bexten, Erdmannsrode, Hönebach, Oberellen and Peesten, on which civic ceremonies or dancing took place periodically (Mössinger 1938a: 145–55; 1938b: 388–96).

Sabine Baring-Gould recalls two that survived in Devon into the nineteenth century (Baring-Gould 1909: 226–29). The Cross Tree at Moretonhampstead was an elm that was pollarded and its branches trained to support a platform, 'railed round, access to which was obtained by a ladder'. In addition to space for musicians, there was enough room for thirty people to sit around and six couples to dance. Another Devon tree, an oak, existed near Dunsford. It was the focus of a curious tenure, that the Fulford family, of Great Fulford, held their lands on the condition that they should dine annually on the tree, and give a dance there (Baring-Gould 1909: 228). Another dancing oak existed at Trebursaye, near Launceston. At Pitchford Hall, near Shrewsbury, is a surviving one-roomed timber frame house in a linden tree, constructed in the middle of the eighteenth century by Thomas Pritchard (Pakenham 2001: 158–60).

Chapter 3
Constructional Principles and Varieties

Traditional Construction in Timber

Timber is an organic material that has variable characteristics. Each kind of tree produces wood with particular qualities that makes it appropriate for certain uses and inappropriate for others. Broadleafed trees produce trunks and branches of varying width which permit the construction of timber frames with members of varying sizes. Conifers are used to construct in a style that requires beams of uniform size, and is preferred for plank or block construction, more common in eastern Europe, the Alps and Scandinavia. Pine, spruce, fir and larch are the main woods used in Polish building. Pine and spruce form the main structure, while the rarer timber from fir and larch are used generally for more complex architectural details, main beams, doors and arcades. Polish manor houses, granaries and churches are usually made of larch (Pokropek 1988: 16).

Timber that has been felled can be used immediately, or allowed to season for a period, when it will be more stable. When it is felled will also affect the quality of the timber. In Italy, Vitruvius (c.13 BCE) advised that timber should be felled between early autumn and the time that the wind called Favonius began to blow (Vitruvius Book II, Chap. IX, 1) In England, the best times are said to be between December and February, when the timber contains the least water. The contemporary French tradition is to fell timber in late autumn and wintertime on a day after the full moon (Walshe and Miller 1992: 24). Then the wood is left in the woods for a few months before being transported to open drying sheds for seasoning.

As an organic material, timber has a fibrous or grained structure and variable density whose character varies between species and is related to where the tree grew. The woodsman's craft is to take

trees from those places which give timber the desired characteristics. Depending on where it came from in the tree, and which way it has been cut, the beams will have particular qualities. The skills of woodsman and sawyer determine what they shall be.

The grain in timber means that it can function both in tension and compression. This depends upon what kind of wood is used, and how it is cut. Beams of large scantling (thickness) function well in resisting flexion. Beams with straight grain serve best as members under tension, whilst timber with a large cross-section can support great weights under compression.

Several types of timber can be converted from the log. For main structural members, this can be a single beam of square section, known as boxed heart; two beams with rectangular section; or quartered, making four square sections. The grain within these members is different in each case, and, when timbers are split rather than sawn, there is a greater inherent strength, for the spit follows the grain rather than cutting through it. The traditional tools for squaring off are the axe and adze. Logs are also slabbed to make planks. Again, the functional characteristics of the planks depend upon which part of the log they come from. Timbers that have not grown straight also play their part in traditional building. They can be halved and used as mirror image timbers as floor joists, braces, in cruck construction and the end walls of *Venntyp* houses of the North Eifel (Bendermacher 1954: 107). In medieval times, split timbers were favoured for joists and rafters. They were used 'flat', that is with their thinner dimension vertical. This allows curving timbers to be used as horizontal supports.

Figure 7. Timber frame variations.

Top row left: Square framing (midlands, south and south-west England).
Top row right: Bracing and decorative framing.
Second row left: Close studding (mainly eastern England).
Second row right: Close studding with middle rail and interrupted sill (as in Pennine and Normandy *pan à bois long* traditions).
Third row left and right: Mann in Frankish framing.
Fourth row: Alamannish *Fachwerk* braces (south Germany)
Left and centre: Versions of the *Schwäbische Mann;* (Swabian mann). *Right: Wilden mann,* with crossing braces.

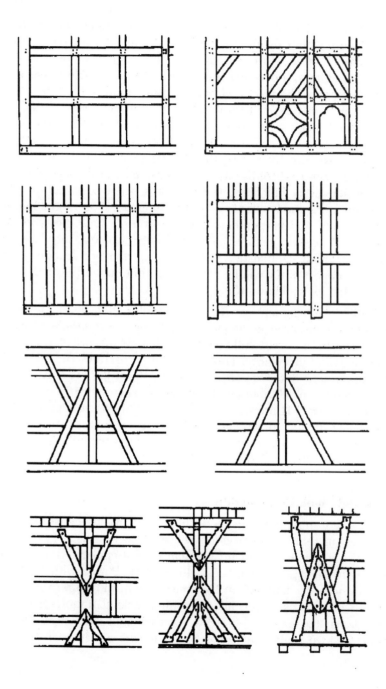

All timber buildings, whether of log, plank or frame construction, are held together by joints. The kind of joints used depends upon the nature of the forces to be overcome. In traditional timber frame buildings, inherently stable joints are used, held in place by wooden pegs. The forces within the frame tend to hold the joints together to ensure structural cohesion. Various forms of mortise and tenon joints serve well under compression, while forms such as the lapped dovetail are strong under tension. Other kinds of joint ensure the overall rigidity of the frame. In timber frame buildings, the roof frames are an integral part of the structure. In stone and brick buildings, the roof is a separate structure, the building being the result of two craft traditions, those of the mason (bricklayer) and carpenter working together. It is therefore an inherently weaker connection. The entire structure of a timber frame building is holistic: each beam in the construction is a necessary part of the whole, at the same time supporting and being supported by its fellows (fig. 7).

Timber buildings can last for a remarkable long time. The sills, roof-plates and grooved half-logs of the Anglo-Saxon timber church at Greensted in Essex still stand (the timbers are original, but the building was dismantled and reassembled in 1845 (Ray 1869)). Beams *in situ* dated dendrochronologically from 1173 exist in a stone house in Freiburg-im-Breisgau, Germany (219–21 Kaiser Joseph Strasse) (Untermann 1992: 234). The oldest dendrochronologically dated timber-frame house in a German town is N° 3, Heugasse in Esslingen-am-Neckar, Baden-Württemberg, which dates from 1261–2 (Schneider 1992: 266).

Log and Plank Construction

One of the most basic forms of building is the log house. French writers on timber construction call it *pièce sur pièce* ('piece on piece'), originally a French Canadian term, popularised in France by Henri Raulin (Guibal 1982: 46, n. 39). Places with plentiful coniferous woodland favour log construction. In northern Europe, the space between logs is filled in with a packing of moss, heather, wood shavings or braided straw. Construction using logs, halved logs or sawn timber planks is by no means a primitive form of

building. Through the years, the artistry of builders in timber has remained ever creative. Timber joints have been developed by unremembered master carpenters as elegant solutions to practical problems. The technical excellence of these multiple forms has gone largely unrecognised by architectural historians. Yet, even in small districts, many possible solutions to jointing have been recorded by folk art researchers (see fig. 6). For example, Halmar Stigum discerned twelve different forms of jointing in the buildings of just one region of Norway (Numedal; Stigum 1945: 71ff). Several types of joint are used in Polish timber construction: the simple overlap joint; peg-and-socket joint; the locking joint; the dovetail or skew; and the hidden dovetail.

In Poland, archaeologists have found locking corner jointing in the fifth century BCE Biskupin settlement (Pokropek 1988: 16) and in early medieval sites at Gdansk and Opole. The castle well at the Hanseatic town of Lübeck, in north Germany, sunk in 1156, was lined with squared timbers with locking joints at the corners. Every seventh course, counting from the lowest, had expanded joints (Fehring 1996: 145, fig. 10). This rare remnant indicates the sophisticated level of technique available to house-builders in the twelfth century. Dovetail jointing appears to have been introduced into Poland by the carpenters' guilds around the fifteenth century, as in the churches of Haczów and Debno. The hidden dovetail joint appeared in Poland as late as the sixteenth century.

In many places in medieval Lithuania and Belarus, castles were built of timber, even the city walls and the bastions of Minsk (Pakomka 1991: 12–14). The timber fortifications of Belozersk, in the Vologda region of Russia, survived until the late seventeenth century (Fiodorov 1976: 10). A form of *murus gallicus* was used in earthworks.

Barn-dwellings are a particular type of plank-constructed building peculiar to Estonia, northern Latvia and Votyak. They consist of three sections, a kiln-drying room, threshing-floor room and accommodation. Approximately 800 barn dwellings and 2600 outbuildings in Estonia have been surveyed and photographed for the Estonian National Museum (Öunapuu 2001: 14–15). Unlike barn-dwellings, built directly upon foundations, Estonian

granaries and storehouses are set upon stones that allow air to circulate beneath the structure. Because of this elevated structure, granaries and storehouses have always had wooden floors. In earlier times, they were halved logs, but more recently, sawn floorboards have been used.

Posts, Sills and Ground Frames

Early buildings were constructed with timber posts sunk directly into the ground. This was not a recipe for long-lastingness. To overcome this problem, carpenters devised buildings whose support came not from earth-bound posts, but by the intrinsic strength of a braced frame. This meant that a building could be supported on stones without any of the timbers being embedded in the earth and thus subject to rot. Certain types of buildings, of necessity, must have structural base frames. Storehouses and granaries, raised above the earth on posts to keep out vermin and predators, require a strong frame structure (Pareli 1984: 116). Perhaps this is the origin of the ground frame.

Free-standing sills or ground frames existed in Gallo-Roman buildings (e.g. at the Gallo-Roman *fanum* at St-Martin-de-Boscherville; Halbout and Le Maho 1984: 13–15). They have been noted beneath box-frame buildings in Brandenburg from the late twelfth century (Müller 2000: 148, 158). In France, a distinction is made between a sill that sits in a trench or upon the earth, and those raised upon stones, drystone walling or masonry walls. The first two are called *soles* and the others *solins* (Halbout and le Maho 1984: 21). Ground frames are the key feature of Norwegian stave churches from the eleventh century onwards. From eight sills arranged in interlocking concentric squares rise the four timber masts that support the tower (Bugge and Mezzanotte 1994: 20–1). Similarly, from their beginning around 1100, post mills were based upon a cross-shaped ground frame.

The timber frame medieval halls of the West Yorkshire Pennines have a post construction which is the same as post-fifteenth century manors in northern France (Faucon and Lescroart 1997: 63). There is no continuous ground frame. The sill beams are not

continuous, but are tenoned into main posts resting upon stone foundations. This is commonly called the 'interrupted sill', recalling a more ancient form of construction which had substituted a stone foundation for the earlier practice of setting the posts directly in the earth. But its apparent antiquity is deceptive. Experience with continuous sills, where the load was concentrated on the beam beneath the main posts, led the master carpenters to create a system where the main posts were supported directly by masonry.

Timber Frames

Traditional timber frame buildings are custom made. Each post, sill, beam, stud, plate, rail, plate, brace and rafter are fashioned by the carpenter to go into a specific place in the structure. Because the 'frames' of the building are put together before erection, each part is identified with numbers and marks that tell where it should go. All marking out is taken from a particular face of the squared timber. This is called the upper face. Particular structural elements are framed up on a framing ground (called *épure* in France) to ensure perfect geometrical accuracy, with the upper face uppermost. Holes to take the fixing pegs are drilled from the upper face, and the pegs are inserted from this side. In the Alamannic *Fachwerk* of Germany, the upper face can be recognised by the ornamentally-cut peg ends.

Frame Typology

Certain simple English timber houses are recognised to have four frames: the wall frame, cross frame, floor frame and roof frame. In the finished building, the upper face of wall frames and cross frames faces outwards. In the case of internal cross frames, the upper face faces inwards in internal halls and the threshing floors of barns. Buildings with a jettied construction are treated as open boxes (fig. 8), with floor, wall and cross frames. The floor of the storey above forms the ceiling of the lower structure, and so on, until the top storey is joined to the roof frame.

45

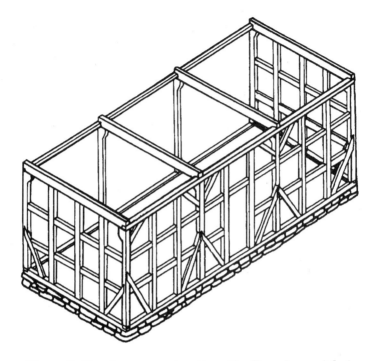

Figure 8. Box frame construction, the French *pan à bois court*, where each floor of a building is an integral framework.

Cruck Buildings

The cruck form of construction comes from the characteristic bent timbers that support the roof (fig. 9). Made by splitting a curved timber in two and setting them up opposite one another, crucks are said to be a very ancient form of construction (West and Dong: 22–3). The received idea is that crucks originated in huts made from rafter poles set in the earth, leading eventually to the use of split curved timbers (an evolutionary theory full of implicit assumptions of 'primitiveness'). However, the oldest extant cruck buildings are perhaps thirteenth century, whilst other, supposedly more modern, forms of framing were used as far back as the Roman Empire. Cruck construction is frequently used with frame

construction, and elements of what would be called cruck in England exist in the so-called *Venntyp* houses of the North Eifel (Bendermacher 1954: 107). Cruck building is another example where a supposedly simple structural form actually consists of many possibilities. Only in north Derbyshire and south Yorkshire in the vicinity of Sheffield, B. Bunker lists nine different forms of ridge-beam (or ridge-tree) supports at the junction of cruck beams.

Styles

The classification of styles of art and architecture often takes place many years after the event. Many of the names given to styles now did not exist at the time they were being produced (e.g. 'Mannerism', 'Victorian', 'Streamline Moderne', etc.). So it is with timber buildings. Classifiers of vernacular architecture divide timber buildings in England and Wales into a number of categories. While these categories are used for convenience, this classification is only an artificial construct that was not recognised at the time of building. Unfortunately, these are very broad categories, without any precisely-definable boundaries, so whether they have any meaning beyond historians' convenience is questionable.

The terminology used in France is more logical than that customarily used to describe English and Welsh buildings. French *pan de bois* construction is divided into two categories, *charpente à bois long* and *charpente à bois court* (long-post and short-post framing). Either form is strictly defined as a timber frame that is self-supporting and does not touch the earth, that is, it has a sole plate or interrupted sill. *Charpente à bois long* has main timbers that run from sole plate to roof. This technique requires very large timbers, and the depletion of trees may have led to it being replaced by a more flexible system. Typically, *charpente à bois long* uses a rectangular frame with diagonal or curving braces. *Charpente à bois court* creates separate frames for each storey, and strengthens the framework with smaller braces, often arranged in decorative patterns. The typical form is the jettied building, where each floor is cantilevered out above the one below it. The typical *charpente à bois court* of France is recognised as

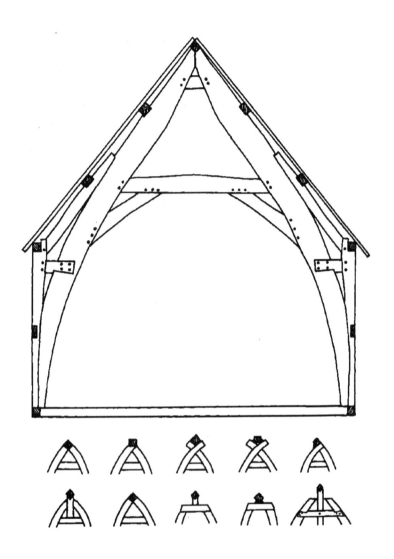

Figure 9. Cruck construction.
Above: The two blades of each cruck truss are sawn from a
single timber, giving a symmetrical structure.
Below: Ten variant forms of English cruck ends supporting
the roof-tree.

Fränkisches Fachwerk (Frankish or Fraconian timber work) in Germany.

English terminology works in a different way, generally ignoring whether there are separate posts for each storey or not. Some British medieval buildings have large panels with arch braces rising from post to plate. These are long-post structures, supporting the whole frame from the ground sill to the wall plate beneath the roof with a single post through more than one storey. Another version of this type of building can also have tension braces, that rise from beam to post (both forms were used in the new Globe Theatre in London). When the design incorporates a window between tension braces, this is known as Kentish Framing.

Close studded buildings, where the short-post frames are made from storey-high vertical timbers set close together, is associated with the 'lowland zone', especially East Anglia. This type was used from the thirteenth to the seventeenth century (Harris 1984: 61). But carpenters also used it in other places. With a rail at mid-wall height, it appears most commonly in seventeenth century buildings in the west midlands and Welsh borders. But it was also used in 1406 in the timber frame church at Melverley, Shropshire, and in London in the gatehouse of St Bartholomew's, Smithfield, (early 1600s).

The 'highland zone' of the midlands, south and south-west is best known for square-framed buildings. Square panels are known from the mid-fifteenth century in Herefordshire, Gloucestershire and Shropshire (fig. 10) (Harris 1984: 71). Later examples are more widespread, from Kent and East Sussex to Cheshire. Some of these have 'decorative framing' based on squares, making patterns from both straight and curved timbers that appear to overlap the basic framework.

The third conventional division is that of the northern 'highland zone', where a subtly different form of close studding is common. Some buildings in Yorkshire have interrupted sills like many manor houses in Normandy, though what connection there is, if any, is unclear. King post roofs pre-dating those in other regions exist here. This zone is also said to have a greater number of cruck buildings than other regions.

Figure 10 (*right*)

Ornamental square framing in various patterns with humanoid corbel, seventeenth century house, Shrewsbury, Shropshire.

Figure 11 (*opposite*)

German timber framing

Top left: Ornamented dragon post in Frankish frame building, Frankfurt am Main, Germany.

Top right: Alamannic *Schwäbische Mann* braces in the *Rathaus* at Esslingen-am-Neckar, Baden-Württemberg, Germany. Note the ornamental pegging.

Below: Timber frame building on a curving site, showing shutters open and closed. Esslingen.

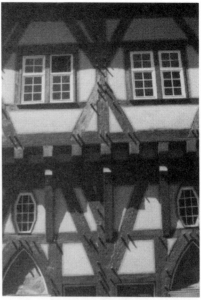
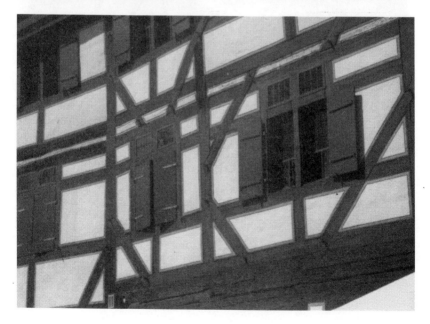

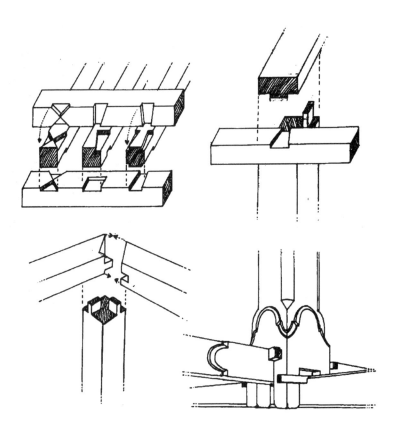

Figure 12. Traditional carpentry joints from
central and north-west Europe.

Top left: Three versions of joint from
Frankish timber framing.
Top right: English lapped dovetail.
Below left: English mitred corner joint.
Below right: Pegged jointing at the base of the
standaard of the post mill at Hondschote,
Oostvlaanderen, Belgium.

The regions where timber framing was the main form of construction in France was, to the west, Anjou, Maine and Normandy; the north, Picardy; in the east, Alsace, Argonne and Champagne and in the midlands, Berry and Sologne. These were the regions where timber for building was plentiful. In Germany, a number of variant styles of framing are recognised. As in France, there is a distinction between long- and short-post construction. The long-post technique is called *Ständergeschossbauweise* and the short-post *Fachwerkbauweise*.

There are three basic styles of short-post buildings: *Niedersächsisches Fachwerk*, *Fränkisches Fachwerk* and *Alamannisches Fachwerk* (respectively, Lower Saxon, Frankish or Franconian and Alamannic timber framing). The first type, Lower Saxon, occurs mainly in north Germany, ranging as far south as the Ruhr and the northernmost part of Hesse. Frankish work is a common form in France and much of Germany. Alamannic work ranges from Alsace to Nuremberg and the river Main to north Switzerland.

The main characteristic of Lower Saxon work is the relatively close spacing of posts, which are strengthened by triangular braces. Frequently, these and the adjacent posts, are carved with sunburst- or flower-motifs and brightly painted. Typically, the lower floor is timber frame.

Frankish work is characterised by well-defined separate frames for each floor, with the ends of the floor-joists left visible. The spaces between the posts are braced with X- and other decorative-shaped pieces (for joints, see fig. 12). In Alamannic work, the main posts are braced with certain characteristic pieces whose jointing is visible from the outside. The most common ensembles of post and braces at top and bottom are called *Schwäbische Mann* and the *Wilden Mann* (Swabian and Wild Man). In the *Schwäbische Mann*, the braces are separate from one another, while in the *Wilden Mann*, the braces cross, giving extra rigidity to the structure. In all joints in Alamannic work, the pegs are left long and carved geometrically at their protruding ends (fig. 11).

In Bavaria, the style known as *Bundwerk*, used for farmhouses and barns, is a long-post style characterised by its bands of close

latticework framing. The oldest known *Bundwerk* building is at Goldau, dating from 1608 (fig. 13) (Werner 1988: 2).

In Poland, timber frame construction is believed to have been introduced from north-western Europe around the thirteenth to the fourteenth centuries (Pokropek 1988: 19). The sill or ground frame rests either directly on the earth, on a stone or brick foundation, or on oaken piles. The first timbers of the ground frame are always made by the locking or peg-and-socket method, even when the upper timbers are jointed differently. These timbers, like the *opasie*, rafter plates that support the roof, are worked more carefully than other structural timbers, with decorative bevelling. Certain granaries and orthodox churches in the Suwalki district of Poland have a vaulted log roof form called *sypance* which is a form of corbelling (Pokropek 1988, 18). A variant of this form of construction was used in Germany in the *Bohlenbälkchendecke* ceilings (as in the Vogthaus in Ravensburg).

Roofs

In timber frame buildings, the roof is an integral part of the frame structure. By the late Middle Ages, every type of timber roof had been developed. The carpenters of old created a wonderfully inventive variety in roof timbering. For spans where long and strong enough timbers were available, simple yet sophisticated forms were used. Roofs in larger buildings may be constructed as a whole that runs from one end of the building to the other uninterrupted, or may arranged as a number of modular bays.

In Britain, there are three basic types of timbering in roofs: the rafter roof, the through purlin roof, and the butt- or tenoned-purlin roof. Rafter roofs are made of individual rafters halved together at the top. Rafter roofs rarely have a separate roof ridge. In central Europe, it is this kind of halved rafter at each gable end that is continued beyond the joint to end in a horse head, cockerel, or other finial (fig. 13) (e.g. von Zaborsky 1936: 279–87). Sorbian buildings with cockerel gable finials are preserved at the Lehed open air museum, Germany. In a 'single roof' type, each rafter is braced by a cross-member (collar) making a rigid triangle. The 'double roof' has a longitudinal beam or plate supporting these

cross-members. This, in turn is supported at intervals by a central crown post rising from the tie beam between the wall plates.

Through purlin roofs are made with a number of trusses that support purlins that rest on top of the truss blades, being trenched into the principal rafter. This type is common in cruck buildings. This form is more convenient to use when pairs of cruck timbers are jointed together on the ground and then raised together. Once the crucks are raised and in place, then the purlins must of necessity be laid upon them, for it is impossible to joint timbers into them once assembled. The rafters are then laid on top of the purlins. In this form, the major structural rafters, supported on posts and linked by a tie beam, have a number of lighter common rafters between them. A variant of this is the clasped purlin roof, which has the through purlins clasped inside the principal rafters at their junctions with a collar.

Butt purlin or tenoned purlin roofs have several trusses with span purlins connected between them by tenon joints. Thus the roof has an integrated structure. The tie beam between the wall plates of a frame construction also serves as the tie beam of the roof truss. Some butt purlin roofs dispense with the tie beam at wall plate level, using a higher level collar and arch braces instead.

Double-rafter roofs are used in vary large timber frame buildings in central Europe, where full-height crown posts are joined with several cross-members before ending supporting the roof ridge beam called the *Firstpfette* beneath the the junction of the rafters (e.g. the *Höhenhäuser* of the Black Forest, some of which are dated 1550 or earlier). Crown-posts supported from the tie-beam called *Spannriegel*, reinforced below by braces, support the *Firstpfette* in large rooms that need unhindered space.

Where the span of the roof was larger than available timbers, as in churches and large halls, other means were found, such as creating aisled buildings where a double row of aisle posts carry beams called arcade plates that in turn support tie beams. Each bay of the roof is thus carried by four posts, a wall and arcade post on each side. Hammer beam roofs, used in churches and large mediaeval halls, are a development of this.

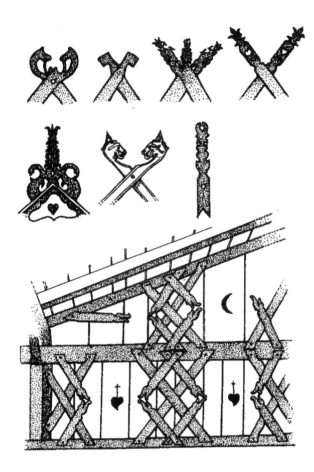

Figure 13. Theriomorphic gable ends and related structures.

Top row, left to right: Grönau, Finsterwalde, Nidden, Gilge,
former East Prussia, seventeenth to nineteenth centuries.
Middle row, left to right: Ulebord gable end, Sneek, Frisia,
eighteenth century; 'gable ends' from the 'tent posts' found
in the c.850 CE Gokstad ship burial, Norway;
hipknob from Brandenburg, Germany.
Below: eighteenth century *bundwerk* in a barn at
Vorderkirnberg, Bavaria, with 'serpents' heads' and heart-
cross and moon-shaped cutouts in the boarding.

Measurement and Building

Nobody can build anything without measuring it in some way. In Europe, numerous different systems of measures and weights, developed traditionally from local usages, were gradually systematised and standardised as the power of nation states gained momentum. The use of local measure often continued in building construction after new systems were introduced.

In England before the standardisation of the foot by King Edward I in 1305, building measurement used several different standards (Skinner 1967: 93). They were the Greek Common Foot, 12.47 inches (317 mm); the Roman Foot, 11.65 inches (296 mm); the Natural Foot, 9.9 inches (251 mm); and the Northern Foot, 13.2 inches (335 mm). Many towns in mainland Europe also had their own foot, shoe, ell and yard; also measures for the size of bread. These can still be seen cut in stone by the door of the main church or watchtower, e.g. Freiburg-im-Breisgau and Berne. Formally laid out towns had regular plots whose size was determined by the local measure. The Zähringer towns of Swabia: Berne, Freiburg-im-Breisgau, Fribourg, Rottweil-am-Neckar and Villingen, were laid out similarly according to Roman tradition with a *cardo* and *decumanus*. But each town had its own measure, appropriate to the location.

Even counting was not standardised until relatively late, the duodecimal coexisting with the decimal system, duodecimal money surviving in Britain and Ireland until 1971. In medieval England, timber was sold by the long hundred, six score (120), written as C. The hundred we know, five score, (100) was written V^{xx} (Hall and Nicholas 1929: x). Around 1253, the *centeine* of 120 boards was recorded in the *White Book* of Peterborough Abbey (Hall and Nicholas 1929: 11). The hundredweight, recently officially abolished in the United Kingdom, is yet a different 'hundred', consisting of 112 pounds avoirdupois. Welsh slates are reckoned by the *mille* of 1200 (Turner 1975: 27), and in Bromsgrove until the twentieth century, nails were made by the 'thousand' of 1200 (Palmer 1992: 162).

The Art of Line

The principles of geometry underlie the construction of all timber buildings (Pennick 1994: *passim*). The tradition of master carpenters in the *pan à bois* tradition of northern France maintains methods that are in principle the same as those of other building carpenters' traditions in western, central and northern Europe. Basic to the French tradition is 'the art of line', the marking out of the forms of timber pieces to be cut. These are worked out geometrically on paper on a small scale, then transferred to a full-scale 'tracing floor' or framing ground, the *épure* (Faucon and Lescroart 1997: 77–9). The method used is ancient and effective. Each form, however complex, is traced simply using straightedge, line and compasses with the knowledge of basic geometry and harmonic proportions. Customarily, the *épure* is used for each component of the framework. In this way, the working of the wood is direct, without drawing on the material to be worked. All geometrical lines run along the faces of timbers, not their centre lines. The geometrical forms define the insides of the buildings, the usable volumes, not the outer shape, which varies according to the local tradition.

The largest surviving timber buildings, such as town halls, manors and warehouses, can be analysed to disclose their inner geometrical principles. The *fachwerk* Town Hall in Markgröningen (near Stuttgart, Baden-Württemberg), built in 1440 (fig. 14), has a rectangular ground plan composed of two equilateral triangles, thus derived from the *vesica piscis* (Rohrberg 1981: 82–3). The triangles meet at a centre-point on the outside of a central pillar. This follows the basic principle that all lines are formed on the outer surfaces of the timber.

In the same region of Germany, similar geometrical principles underlie the structure of the town halls at Besigheim, Esslingen-am-Neckar, Kayh and Strümpfelbach. A fine example is the sixteenth century warehouse in Geislingen-an-der-Steige called *Der Alte Bau* (The Old Building). This has the height of an equilateral triangle as the ratio of the basal width to the height of the main frame. Internally, the level of each floor is defined by the apices of smaller equilateral triangles drawn within the larger ones (Rohrberg 1981: 53–5).

The techniques of master builders included graphic means of recording the dimensions and proportions necessary in construction. The entire elements of a building can be set out in a single parametric diagram (Pennick 1992b: 291–2). The drawings of the Byrom Collection are a rare survival from eighteenth century England.

Transported Buildings

Timber frame buildings are not made on site, but as frames constructed by carpenters on the framing ground at the saw-pit or sawmill. The timbers are numbered, and signified by various marks to show where they fit together. They are then transported to the building site, where they are assembled. For more than 1,000 years, timber frame buildings have been transported over large distances by ship. Perhaps because of the lack of timber on the island, the first Norwegian settlers of Iceland (in the period 870–930 CE) transported holy buildings there. The Goði Thorolf Mostur-skeggi dismantled his temple in Norway and shipped it, with the earth beneath it, to Iceland. When he came close to the coast, he cast overboard the high seat pillars, on one of which was carved an image of the god Thor. Where they came ashore, there he erected the temple (*Erbyggja Saga* 4). *Laxdaela Saga* (74) tells how, in the time of King Olav (reigned 1015–30), Thorkel Eyjólfsson fashioned a church in Trondheim for transportation to Iceland. In 1066, the forces of William of Normandy brought with them a timber castle which they erected shortly after they began their conquest of England.

England has long imported timber for building. From the thirteenth century, deal (fir timber) was brought to London from the Baltic lands as *Estrick Board*, named after the ports from which it was exported as Memel or Riga Fir. From the seventeenth century onwards, it was imported mainly for floorboards. Sometimes, whole buildings were imported, ready-made. In the mid-1500s, Nonsuch House, a magnificent four storey timber frame building that stood on Old London Bridge, was made in Holland and erected in London (Shepherd 1971: 40–1). In the eighteenth century, import of ready-prepared timber from

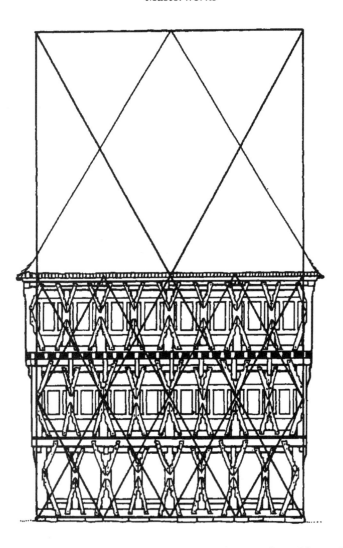

Figure 14. The art of line. Geometrical analysis of a gable end of the *Rathaus* (town hall) at Markgroningen, Baden-Württemberg, Germany (c. 1450). The geometry is *ad triangulum*, based on the equilateral triangle. The height of the building is equal to half its external length, measured from the outside faces of the ground frame or sill. The placement of significant points in the framing are defined by the ruling 'art of line'.

Holland, where the wind driven sawmill had greatly reduced the cost of sawn timber, was prohibited in Britain.

Sometimes, owners moved their timber frame buildings from one location to another. Several buildings in Hereford are not on their original sites (West and Dong: 177–9). The town hall at Bridgnorth, Salop, was moved there after the earlier one was burnt during the Civil War in 1646. An existing timber frame barn was obtained from Much Wenlock, and reconstructed on the remaining stone pillars of the former civic building (West and Dong: 179–80). In more recent years, numerous timber buildings have been taken down and re-erected at open-air museums all over Europe.

Frequently, timbers have been re-used in part in other or new buildings. They may be identified by extraneous joints and mortices, or carpenters' numbers out of sequence. Some old houses in Brussels contain notable timbers salvaged from patrician buildings demolished by French artillery fire in 1695. Local oral culture all over England tells that houses contain timbers taken from ships, but this may come from a misinterpretation of the term 'ship's timber', a technical term for a particular quality of timber, rather than literally from a ship (Harris 1984: 19). Dendrochronology is of great help in identifying re-used timbers.

Timber Buildings for Railways

The great expansion of railways in the mid-nineteenth century, especially in carrying passengers, meant that a great amount of new building was needed each time a new line was laid. Major stations in important cities and towns were always imposing buildings of stone or brick in a particular 'polite' architectural style. Even the signal cabin at the original Edinburgh station was an eclectic architectural gem, with quoins, gable clock, roof urns and a Baroque 'onion' pinnacle with weather-vane. But for many companies, most signal cabins, goods sheds and rural stations were constructed largely of timber, prefabricated in the company workshops. In doing this, the railways continued the practice of the timber frame builders of earlier times. But the bulk production of these components was a new departure.

Along with several other companies, the London and North Western Railway developed standardised modular timber buildings whose components could be combined (fig. 15). A few of them remain. There were notable timber station buildings on the Furness Railway in north-western England. Companies that did not go in for 'system-built' stations and signal cabins often built everything in brick. Local and light railways often had far more rudimentary structures.

London and North Western Railway buildings were constructed in timber framing externally clad with tongue-and-groove 'rusticated'

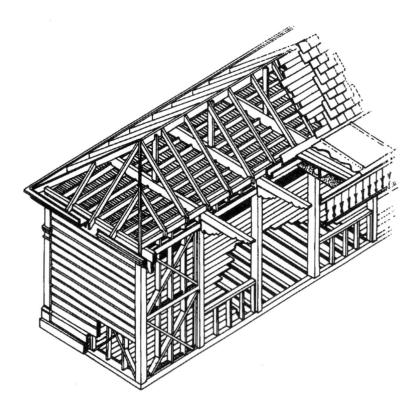

Figure 15. Sectionalized drawing of a London and North Western Railway standard timber frame station building, c.1860.

boarding. Corner posts were seven inch square timbers, whilst intermediate posts were thinner, spaced at centres of 6 feet 8 inches. They were supported by a sill six inches square, anchored in place by iron bolts that ran down through the middle of brick foundation piers constructed on a stone base. There were three types of main side wall: plain wall frames, frames with windows and two types with doors, single and double. Plain wall modules were stiffened with a double X-braces, whilst in the window modules, the windowsills were supported by vertical studding. End walls were strengthened by four X-braces. Internally, the walls were boarded. Roofs were covered with Countess (10 by 20 inches) slates from Wales and blue Staffordshire ridge tiles.

Railway station canopy valances showed the greatest variation in pattern. Related to shingle designs, the pointed or rounded ends of each piece allowed rainwater to drip easily from the canopy. In the 1960s, many stations had the ends of each valance shingle sawn off to a straight line in an attempt to appear modern, so even in places where the old stations have survived, the characteristic local design may be no longer present.

Although in Britain, iron and steel girders replaced timber for new industrial buildings in the nineteenth century, in countries where timber was plentiful, builders continued to use it. The large tramshed called Betriebshof Bad Cannstatt, built in 1929, from which the last narrow-gauge tram route in Stuttgart, Germany, is operated (the rest of the system having been converted to standard gauge (4 feet 8½ inches or 1435 mm) between 1985 and 2002), has a roof of timber frame construction spanning eight metre-gauge tracks. Another surviving timber-roofed tramshed of similar size in the city, now a museum, dates from 1936, while one dating from 1913 was demolished in 1989 (Bauer and Theurer 2000: 257, 260, figs. 275, 277, 297).

Bricklaying and Brick Walls

Bricklaying is a traditional skill that has not passed away (fig. 16). In Britain the craft is maintained to a high standard, and the accuracy and quality of the best British brickwork is superior to that in most of the rest of Europe, where brick walls are usually

Figure 16. Late sixteenth century English Bond brickwork at Niederzier, Germany, with structural timber window surrounds and masonry-derived relieving arch.

stuccoed and inaccuracies are invisible. However, brickwork in British speculative building rarely shows the subtle possibilities of bond and pattern that brick building permits. The name of each type of bond describes the arrangement of brick upon brick, each bond having been developed to serve a particular purpose.

Bricks are standardised to be half as wide as they are long. This enables them to be laid in double rows, creating the standard 'one brick' or 'nine inch' wall. Although brick sizes have varied with locality and through time, the traditional English brick measures 9 inches by 4½ by 2½ inches. The upper limit of size of standard bricks has been round about 9½ by 3¾–4¾ by 2½ inches, though the thickness of the 9 by 4½ inches brick varied up to as much as 3¼ inches during the nineteenth century. British bricks are now officially 'metricated' to 215 x 102·5 x 65 mm (Brunskill 1987: 47).

Bricks laid longwise in the wall are called stretchers; those crosswise are headers. Because bricks are a standard size, and buildings may not be, bricks have to be cut to make the length, usually near the corners so that the pattern of most of the wall is not disrupted. These cut bricks are called closers. In the bricklaying tradition of Sussex, when a brick is cut across its face lengthways and laid, it is called a queen closer; one with an angle cut off is a king closer.

Figure 17. Brick wall construction.
Top row left: English Bond.
Top row right: Flemish Bond.
Second row left: English Cross Bond.
Second row right: Dutch Bond.
Third row left: Double English Cross Bond.
Third row right: Monk Bond.
Fourth row left: Stretcher Bond.
Fourth row right: Header Bond.

There are many variant ways of laying bricks (fig. 17). English bond is laid with alternate regular courses of headers and stretchers. English cross bond has a variation on this, where the alternate courses of stretchers are moved over by the space of half a brick. In double English cross bond, a double course of headers alternates with a double course of stretchers. There are other possible permutations of English cross bond.

Header bond is laid completely with headers. It is often used for walls that curve a little. Laying all the bricks the other way, stretcher bond is made by laying stretchers that overlap the course below by half a brick. It has no cross-bonding, and so is preferred for cavity walls, when the bricks are linked periodically by metal ties. This is the brickwork bond used in most contemporary housing developments. In raking stretcher bond, courses are laid a quarter brick along upon one another. This gives a more interesting pattern of mortar lines. Monk bond has courses composed of two stretchers then one header, and so on. The joint between the two stretchers lies over the header below.

Flemish bond lays bricks in which alternate headers and stretchers compose each course. The headers are centred over the stretchers. From the seventeenth century, Flemish bond was used right across Europe, as far east as Russia. Dutch bond uses headers that are laid half a brick over one another. In Dearne's bond, stretchers are laid on edge, alternating with normal headers as in English bond bricklaying. This is not a very strong structure, because it is not solid, so it is reserved for garden walls and outhouses. Similar is rat trap bond, where all bricks are laid on edge in Flemish bond pattern.

Other bonds are not structural. They appear as nogging in timber or reinforced concrete frame buildings or as cladding over concrete. Stack bond is where the bricks are laid upright directly upon one another. Using different coloured bricks, the geometries of the various kinds of bond allows the bricklayer to create decorative patterns (Field 1996: 20–7). Early brickwork from the sixteenth century, examples of which exist in Cambridge colleges, often contains diaper-work patterning in contrasting coloured bricks. With Flemish bond, chequered patterns are produced by

alternating the type of brick used for headers and stretchers. Red brick buildings with contrasting dark brown or black brickwork making rune-like patterns was popular in the English midlands in the nineteenth century. There are some good examples in Huntingdonshire.

Bricklayers have always had to cut or rub bricks to make them fit awkward places. Cambered brick arches above windows demand a particular skill in brick rubbing, so that each brick takes on an appropriate wedge shape. Frequently, however, special *vouissoirs* have been made at the brickfields to ease the bricklayer's task. In the nineteenth and twentieth centuries, mass-produced bricks included various decorative forms, including mouldings and ornament derived from classical, medieval and renaissance patterns.

Chapter 4
Function and Pattern

Traditional society is holistic in its approach to doing things. The arts and crafts techniques used in building are in no way separate from those used in other elements of traditional society. If they are categorised by function rather than structure, this tends to alter the perception of the nature of the craft. This can give the appearance of the existence of separate trades in the past when in actuality the same craftsperson in a locality turned his or her hand to every possibility within the remit of the craft. Here, related functions are dealt with together.

Wattle and Daub

The most basic form of infill for timber frame buildings is 'wattle and daub'. Wattles are made from short staves of hazel, between which are woven withies of willow. The ends of the hazel are sharpened to allow the wattles to be sprung into mortises or grooves cut in the lower and upper faces of the structural timber (fig. 18). Once in place, the spaces between the withies are plastered over inside and out with wet earth or clay, a technique known as 'tosching' (called that at the Tower of London in 1278) or, more commonly, daubing (Willett 1980: 11). To the earth, a binding agent such as dung, cow hair, horsehair or straw was often added. Outside and in, the walls were then whitewashed, or, in more affluent households, covered with plaster.

Hurdles and Gates

Part of the same craft as making panels for wattle-and-daub walling is hurdle-making. Wattles woven from hazel and willow vary in pattern according to district and county. Variations are largely in the way that they are woven. The basic hurdle is six feet long by between three feet six inches and four feet high. It is woven in willow withies around ten hazel zales (uprights), each of which is

sharpened to allow it to be rammed into the ground. The two or four hazel zales at each end are often longer at the top to allow them to be fixed to overlapping adjacent hurdles or a post by a hazel shackle. In the centre of the weaving, a twilley hole is left to allow the shepherd to carry the hurdle. The form of this varies with locality. Most hurdles made now are garden screens, variants of the traditional sheep hurdle. They have a greater variation in height, but lack twilley holes.

At the borderline between woven hurdles and carpentry are gate hurdles. Strong enough to be durable and resist livestock, but

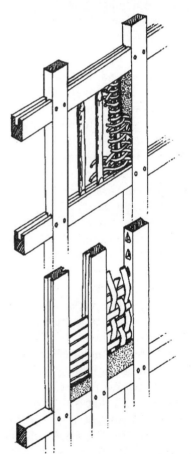

light enough to be carried easily by a man, they were used as temporary fencing wherever animals needed to be penned in. Being openwork, they are not so resistant to wind and rain as wattle hurdles. From the times of 'Turnip' Townshend in the 1730s, in East Anglia sheep were folded in wintertime on the turnip crop by means of gate hurdles. Through this innovation

Figure 18. Timber frame infilling.

Top: Wattle and daub. The top of horizontal timbers are grooved, and the bottom is drilled with holes to take the hazel staves around which the withies are woven.

Below: In close studding, the verticals are grooved to take laths, or have holes cut for horizontal staves around which laths are interwoven.

of feeding the sheep in wintertime, fresh meat was available all year round (Tabor 1994: 122).

As with every traditional craft, gate hurdles show local variation, for instance a Kentish hurdle measures eight feet long, whilst one from East Anglia is only six feet. There is a standard form, consisting of a sharpened upright at each end (for hammering into the earth), a number of horizontal rails (called 'ledges' in Suffolk and 'slays' in Kent) and usually three braces. One brace is at the centre, and vertical, with one on each side at an inclined angle to it. Hurdles to keep in pigs and bullocks are correspondingly larger and more sturdy than those for sheep. But making gate hurdles requires skill, so they have been largely superseded by portable wire electric fences driven by lead-acid batteries with all the ecological consequences.

Before they were superseded by tubular metal, all field gates were made of sawn timber by local carpenters. Traditional field gates are made from hardwood. Heart of oak, or less commonly, chestnut, is preferred. Yew is the gatepost of choice, being a wonderfully strong wood. The part above ground is squared off by the carpenter, while the part embedded in the earth is left unworked. Like gate hurdles, the strongest parts of a field gate are the two upright posts, one thicker than the other. The thicker post, which hinges against the gatepost, is called the heel. The thinner one is the head. The uprights are connected at top and bottom by two rails, between which are a number of horizontal bars (but, confusingly, when bars are counted, as in a 'five bar gate', this means both rails and bars). All rails and bars are mortised into the uprights. The bars are not spaced evenly, the lower being closer together to prevent lambs getting through the gaps. Diagonal braces, whose patterns vary according to region or county, keep the framework square. All joints are pegged by dowels hammered into drilled holes, as in traditional timber frame buildings. Hinges and catches of traditional gates are custom made by blacksmiths. Hinges have two components: the gudgeon (or eye) and the pintle. The gudgeon has a pointed shank or forked end that is driven into the heel post of the gate. It then hangs on upright pivot of the pintle that has been driven into the gatepost. Hanging a gate in this way is a skilled job, for everything must be lined up properly if the gate is to hang well.

Nogging

A form of nogging, as a stone infill between timber posts, existed in ancient times in one form of *murus gallicus*. Roman builders infilled timber frames with stones and concrete as *opus craticium* (Marta 1990: 31) In Poland, the infill of timber framing is frequently *pecki*, unfired clay bricks similar to the East Anglian 'clay lump' bricks. In England, brick nogging is said to have appeared first in East Anglia and the south-east, using bricks imported as ships' ballast (West and Dong: 123). Some houses have bricks that appear to have replaced earlier wattle-and-daub. Because the timber, and not the bricks, is the load-bearing structure, the bricks can be arranged in decorative, rather than structural, patterns.

Nogging patterns have their own names, such as 'herring-bone' and 'basket-weave' (fig. 19) (Field 1996: 14 – 15). Brick nogging with a very inventive repertoire of patterns is found in parts of Germany, especially the lower Elbe region. They include 'herring-bone', zigzags, crosses and imitations of woven patterns. Particular images made in brick nogging include pictograms of post mills and the sign called *donnerbesen* ('thunder broom') (Herrmann 1942: 333). There is also openwork nogging for ventilation, including the *mann* pattern like that in timber framing.

Pargetting

Pargetting-work or 'Dandying', the craft of making patterns in plaster on the outer wall cladding of timber frame buildings, is a familiar sight in the eastern English counties of Essex, Suffolk and south Cambridgeshire (fig. 20). It also exists in the form of more or less isolated examples in Devon, Hertfordshire, Herefordshire, Kent, Leicestershire, London, Oxfordshire and York.

Some pargetted designs are complex hand-moulded images, such as beasts and birds, mythological figures and symbols. More commonly, the patterns of pargetting-work consist of rectilinear panels defined by beaded bands, containing stamped or moulded figures and tessellations, artfully and symbolically arranged with respect to the structure of the building. Although the technique may have been derived from interior ornamental plastering,

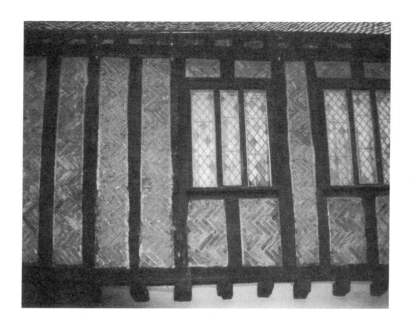

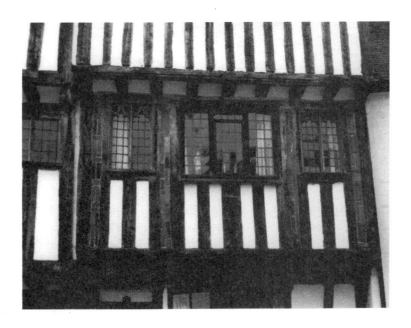

especially the ceilings of upper class houses, the essential place for pargetting is on the outside of vernacular buildings in villages and towns, where it brings interest and 'local colour' that otherwise would be lacking.

Although pargetting work can be made on wattle-and-daub or brick-nogged walls (even rubble or brick walls) the development of lath and plaster walling facilitated the art. In this technique, thin riven timber laths are nailed closely to the outer side of the building's timber frame. Then two coats of plaster are applied to the outside of the laths. Inside, lath and plaster also makes the inner walls of the rooms.

As with all traditional crafts, organisation, timing and consistency are the fundamental elements of successful application. The many sequential processes of pargetting described below may be taken as an analogue of the processes in most other traditional crafts. The traditional materials used in pargetting have also stood the test of time, though contemporary pargetters usually use ready-made proprietary materials.

In former times, the materials were mixed on site a month before they were to be used. Firstly, the sand was screened to remove stones. It was then made into a ring on the ground, and two planks laid across it. A sieve was then supported on the planks in the middle of the sand ring in readiness for the mixing procedure.

Lumps of lime were mixed with water in a wooden tub. Once it had attained a cream-like consistency, the lime was poured through the sieve into the centre of the ring of sand. Next, cow hair was stirred into the mixture using a special tool called a hair hook. Then, using a larry, a kind of pusher with a long handle, the

Figure 19. Brick nogging in close-studded timber frame buildings.

Top: Herringbone patterns, Norwich.
Bottom: Stack bond with cross-stretchers interspaced with plastered panels. Thaxted, Essex.
The Norwich building has lozenge-shaped 'leaded lights', including occasional green glass quarries, whilst the Thaxted house has rectangular panes that include crown glass roundels.

ring of sand was pulled into the centre, and mixed with the lime and cow hair.

Finally, the mixed mortar was left in a heap. It was then left on site to mature until the plasterers came to parget the house a month later. Contemporary pargetters do not mix their own mortar in this way. They use 'the modern mix', generally consisting of 5 parts sand, 1 part proprietary cement and 1 part commercial Hydralime (Willett 1980: 14). Animal hair is still used as a binding agent.

The technique of pargetting requires plasterers' tools. The mortar is carried on a hawk, a board a foot square, held by a wooden handle beneath it. It is spread on the wall with plasterers' trowels and various-sized floats, essentially smoothing boards with handles. Once the first coat of mortar is on the wall, to make a binding surface for a second coat, pargetters use a wire scratcher, a tool that looks like a wide paintbrush, but with stiff wires instead of bristles. The surface must always be scratched with wavy lines, because criss-cross straight lines will let the top coat of mortar shell away too readily. Finally, a third coat is added.

The top coat of mortar is most important, for this bears the actual patterns of the pargetting. Before the top coat is put on, the positions of all of the beaded bands are chalked on the walls, checking verticals with a plumbline and horizontals with a spirit level. The beaded bands always follow and emphasise the structure of the building. The places where the beaded bands are to be made are rendered with mortar first, and marked out using a wooden gauge rule, beginning at the top and working downwards. The customary space between beaded panels is five inches. The rectilinear beading is made with a hardwood beadstick, which forms the section of the moulding. These are usually single, but some pargetters use beadsticks that make two beads at once.

Usually, pargetted patterns are made within the panels defined by the beaded band borders. There are several possible techniques, and all have been used somewhere or other. In Clare, Ipswich, Saffron Walden and White Colne, among other places, are notable seventeenth and eighteenth century pargetted buildings which boast complex hand-moulded ornament. In style, this ornament ranges from Jacobean to Baroque. Ancient House (Sparrow's

Figure 20. East English pargetting. Varieties of press-tool work in Saffron Walden, Essex.

House) in the Buttermarket in Ipswich, Suffolk, has allegorical figures of the four continents, swags of fruit, trophies and other emblematical symbols, whilst the Old Sun Inn in Saffron Walden, Essex, has cranes, suns and a combat scene that may represent a mummers' play. More recent hand-moulded work can be seen on houses and inns in various parts of Essex, especially.

Far more common and characteristic are the tessellated patterns made from press tools or combs. Press tools are carved from wood or cast in Plaster of Paris treated with shellac to preserve the surface against the damp plaster. Combs are made from hardwood or zinc, with an engrailed edge on the comb end that allows it to run freely through the mortar, giving a smooth finish.

Once the beaded border is ready, mortar is applied to the field within, and pattern making commences. The pargetter begins at the top left corner, and works across to the right, line by line. Common press tools make patterns that resemble scales. There are several variants of this form, including the fan and sunray patterns, invariably used with the semicircular part uppermost.

In addition to overall tessellations, the form of these stamps enables the pargetter to create many variant patterns. When they are made into a cross form, they create a four-leafed pattern, sometimes expanded into a cross by more stamping. Other images are derived from British heraldic devices, such as the fleur-de-lys, crown, bell, thistle and Tudor rose. Rarely, pargetting includes whole heraldic shields. Five-petalled Tudor roses are either moulded by hand or made from petal-shaped press tools. Some public houses have their emblem and name in pargetting work.

Much pargetting is so expertly executed that one may not be able to tell whether the pattern has been made by a press tool or a comb. The comb is used mainly in creating the weave pattern and a version of the sunray pattern. Starting from the left-hand corner, the pargetter first makes a horizontal sweep, next a downward, and so on. Each 'sun ray' requires a regular sweep of the comb, and, like the regularity of the weave pattern, this is the measure of the pargetter's skill. Interlaced cablework patterns can also be made with the comb.

In addition to the comb, zigzag templates of wood or zinc are used to create vertical herring-bone patterns. There are two ways of forming this. One involves pricking dots in the mortar along the template of the zigzag. The other follows the zigzag to make continuous lines.

Finishing work added to either stamped or combed work, adds lines to make leaves, emphasises patterns, and fills awkward spaces. For this, the special wooden small tool, or the neck or bottom of old-style bottles can be used. Bottle necks are especially useful for the central indentations of flower-like patterns. Actual objects are used sometimes, such as a horse's hoof and horseshoes. In Thaxted, Essex, there are four horseshoe impressions surrounding crossed riding crops on a pargetted building. In Saffron Walden there is a small wheatsheaf that may have been made from a carved wooden butter mould.

The background work outside the beaded borders was traditionally smooth. Since the 1960s, however, rougher backgrounds have come into favour, perhaps influenced by the vogue for roughcast concrete in building, 'Artex' and other 'rusticated' commercial finishes. They are often accompanied by modern renderings of traditional themes.

Bone Floors

Bone is a very hard and durable substance, and in pre-industrial society, many tools and implements, including needles, combs, buttons and handles, were made from the material. Among the practical uses of bone is flooring. Bone floors were common in Oxfordshire, sometimes composed in geometric patterns made from the ends of horse and cattle metapodials, as in an Oxford house at George Street, demolished in 1894 (Caton 1988: 25). A seventeenth century house in Broad Street in that city had a floor of 'trotter bones' laid in patterns (Innocent 1916: 159). Horse bones and sheep jawbones existed beneath the floor of St Botolph's church in Boston, Lincolnshire (*Notes and Queries*, 1st Series V, 274). A house at Fulbourn in Cambridgeshire had a hall floor of sheep bones (Evans 1966: 200), whilst a seventeenth century

house at Bungay, Suffolk, had forty horse skulls laid in regular rows beneath the floor (Mann 1934: 253–5). Similar horse skulls are reported from cottages at Halton East, Yorkshire (Evans 1966: 198–9). Irish tradition recorded by George Ewart Evans asserts that skulls laid beneath the flagstones of a house improve the sound when the occupants dance there (Evans 1966: 198–9). The burial of horse skulls beneath each corner of threshing floors is reported from Ireland, south Sweden and Denmark (Evans 1957: 216). Irish floors were sometimes strung with wire 'to make the flails sing', though a horse skull beneath each corner of other rooms has also been noted (Leather 1914: 110).

Where bones are found in the roof of a house, it is possible that this is not some kind of primary magical act, but the remains of local techniques of roofing. In some places, stone flags are fitted to the roof by sheep's bones (Brunskill 1987: 89), and it is also possible to use bones in thatching. In addition, the technique used in Ireland, the Hebrides and the Scilly Isles of holding down thatch with ropes or netting, requires fixing materials such as stones and pegs, which may have been of bone.

Window Shutters, Grilles and Glazing

In the days before glass was available, windows were either open to the air, or shuttered. Wooden shutters are like small doors that plug the gap in the wall that is the window opening (fig. 11). Often, they are not completely solid, but have small holes or openings cut in them to allow ease in handling the shutters (like the twilley holes in hurdles) and to let in some light. These holes are frequently patterned. Some old shutters have gudgeon and pintle hinges, but in central Europe, traditional hinges are ornamental, conforming to local traditional patterns. I have seen new ones on sale in hardware shops in Alsace.

Shutters were once common in Britain, but the few that survive on old buildings are hardly ever used, being permanently pegged open. New buildings rarely have shutters, despite their usefulness for security, protection against stormy weather, and helping to reduce fuel bills. In mainland Europe, where people shut up for the night, most traditional shutters have been superseded by metal

roller shutters, though in conservation areas, traditional shutters are renewed when necessary using the old designs.

Along with making baskets for every possible purpose, the medieval withy weavers made curved wickerwork grilles that protected ground floor windows. They appear to have been superseded by iron grilles or glazed windows, and the art of making them seems to be no more. Their distinctive form can be seen illustrated in many of Peter Breugel's paintings and drawings, such as *The Ass at School* (1556), *Gluttony* (1557), and *The Flemish Proverbs* (1559), where 'the shears are hanging out front'.

As well as wickerwork grilles, diamond- or lozenge-shaped glass quarries can be seen in Peter Breugel's painting, *The Battle of Carnival and Lent* (1559). These are the classical traditional window panes (fig. 19, top). There is no standard geometric form, though sometimes double equilateral triangles or Egyptian diamonds can be found. In England and Wales, Tudor and Jacobean windows of the houses of the well-to-do frequently have quarries arranged in symmetrical tesselations of geometric forms. It is into these kind of windows that small painted glass panels, sometimes rescued from destroyed monasteries, were inserted.

Mondscheibenverglasung, literally 'moon pane glazing', the Swabian *Scheibefenster*, is made from circular panes of crown glass about ten inches diameter. Set in lead calms with triangular infills, *Mondscheibenverglasung* is a feature of traditional buildings in central Europe. Originals can be seen in the Vogthaus at Ravensburg and Waldenbuch Schloss, Baden-Württemberg, Germany, both sixteenth century buildings that are now folk museums.

Using circular panes was a theme taken up by Arts and Crafts architects after their use by William Morris and Company in the Green Dining Room at South Kensington (now the Victoria and Albert Museum), 1866 (Parry 1997: 140–1). Subsequently, Charles Kempe installed circular panes in windows at Wightstock Manor, Staffordshire (built 1887 to 1893). Derived from fifteenth and sixteenth century German prints, they appear in paintings and book illustrations of the period, most notably in Sir Edward Burne-Jones's engravings in the Kelmscott *Chaucer* (1896). The Austrian

architect Joseph Maria Olbrich modified this central European tradition in his windows for the Villa Friedman in Vienna (1899) (Olbrich 1904, pl.33). At the same time, it was also favoured by the Finnish Arts and Crafts architect Axél Gallén.

Much ecclesiastical glass was destroyed during the Reformation, when the monasteries were dissolved in England and Wales (1530s). Later, during the Civil War and Cromwell's reign (1642–59), iconoclasts travelled the land smashing church windows depicting religious images. Fragments of this smashed glass were recovered and leaded up as windows in new buildings. The use of shards and fragments

Figure 21. English Arts and Crafts glass-in-lead panelling in a carved wood door, using slab glass, painted and stained glass fragment and crown glass roundels. Liberty and Company, the Tudor Building (early twentieth century), London.

created a new style of leaded glass, where formerly figurative pieces were assembled abstractly. Amid strictly geometric quarries appear small pieces, leaded into patterns suggested by the shape they formed when they were broken. Towards the end of the nineteenth century, this abstract and particularly English style was adopted by some Arts and Crafts glass craftsmen. It appears in the 'Tudor Building' of Liberty and Company's store in central London (fig. 21), and in the many public houses built for William Younger's brewery (e.g. 'The Fountain', St Andrew's Street, Cambridge, or 'The Wheatsheaf', Rathbone Street, central London).

Thatch, Reed and Straw Work

Traditional thatched roofs are made from local materials: bracken, heather, reed, rushes, sedge and straw. Thatch made from ling, long-stemmed heather, is traditional in Ireland, the Welsh highlands, the Hebrides and the Scilly Isles. This kind of thatch is secured with ropes or netting, requiring fixing materials such as stones and pegs of wood or bone. Frequently, in former times, such ropes were made of straw, a craft used in thatching ricks. In most places, where thatch is used at all, chicken wire has superseded the traditional ropes (Nash 1991: 37–8). Reed from estuarine marshes, most notably Norfolk reed, makes the most long-lasting thatched roof (fig. 22). Norfolk reed grows not just in Norfolk, but also in Cambridgeshire, Essex and Suffolk. Long straw from arable land is another alternative roofing material. From the mid-twentieth century, the declining length of wheat-, oats- and barley-straw has made the craft of thatching more difficult.

Where thatchers have not cut corners, and used less long-lasting metal fittings, the thatching material, whether it is reed or straw,

Figure 22. The undulating roof-form of traditional English thatch on a house in Oakington, Cambridgeshire. The outbuildings have eighteenth century pantile roofs.

is supported and held in place by wooden rods of different shape. The roof rafters are connected together by laths, binders or sways, which are round or cleft lengths of hazel five to eight feet long around an inch in diameter. They support the underside of the thatch. Liggers or runners are three to five feet in length, cleft from 1½ inch rods. These are used on the outer side of the thatch to secure the ridge and eaves. Between liggers are cross rods that help to hold down the ridge. These are secured by broches, cleft rods bent and sharpened at each end, hammered into the thatch. (Broches is a Suffolk term. As with many crafts, names of components vary from district to district. Broches are called springles in Essex, spars in Dorset, and stakes or spits in Wiltshire; bones have sometimes been used as broches (Tabor 1994: 96).)

Straw, the by-product of grain farming, has many uses other than thatching. Straw rope or netting was used in the western seaboard of Europe to tie down roof thatch. Thatchers commonly make ornamental roof-finials in the shape of birds or animals as a finishing touch. These are also a display of skill and the maker's personal signature.

Traditional bee-skeps are made from straw rope, rye straw if available, wound round and round into the shape of a drum or dome, and stitched together (Rentschler 1926: 42–3; Seymour 1984: 164–5). Straw has also been used for hats (made and worn now) and shoes. Some straw wear has been temporary and ceremonial in use, such as the Hallowe'en caps of County Down (Evans 1957: 278) and the 'witches' shoes' of the present-day south German *Fastnacht*.

Traditionally all over Europe, the last sheaf of the harvest has been taken triumphantly back to the community, and honoured in some way. There has been much written about the rites and ceremonies of the harvest, and many contemporary writings on how to plait straw are heavily influenced by the speculations of Sir James Frazer (cf. Frazer 1922, chapters 45–47 on the 'corn-spirit'). Although it was not used generally until the twentieth century, the name 'corn dolly' is used generically now to describe any of the numerous and very different forms of straw plaiting that have been made traditionally in different parts of Europe. In *The Folk-Lore of*

Herefordshire (1912), Ella Mary Leather refers to them as 'wheat plaits' (Leather1912: 104, illustration opposite p. 87).

The origin of the name corn-dolly may be traced to a meeting of the Folk-Lore Society in London on 20 February 1901, when Alice B. Gomme exhibited what she described as a 'Kirn Maiden or Dolly' copied by a Miss Swan from 'those made at Duns in Berwickshire' (*Folk-Lore* 12 (1901), 1, 215–6). Later offerings on the subject in *Folk-Lore* until World War II call them by their actual names, e.g. 'Kern Babies', 'Necks', 'Hare', etc., not 'corn dollies'. But at some point after that the name became the generic for straw plaits.

In Britain, there are many different recognised forms of straw plait, some of them with names that reflect their origin, such as Badsey's Fountain, the Charlbury and Suffolk crowns, the Double Mordiford, the Topsham Cross, and the Tyrolean Plait (Sandford 1979: 9–67). Some taken from old traditions, and some have arisen since the craft was disseminated widely in Britain after 1951 by the Women's Institute (*vide* Croker 1971; Sandford 1983).

In 1951, the organisers of the Festival of Britain arranged for surviving masters of the craft to make masterpieces for demonstration of the ancient craft. Old and new straw plait designs were put on show side by side. The Essex plaiter, Fred Mizen, made a straw lion and unicorn (Cooper 1994: 62). The Worcestershire man Arthur 'Badsey' Davis, part of a family who transmitted the craft through the male line, is recalled as one of the grand masters of straw plaiting (Sandford 1979: 56). His masterpiece was to plait a crown-shaped structure from forty-nine straws, now known as Badsey's Fountain. This design probably originated as 'the crown of the rick' as hayricks were thatched and finished with similar ornamental plaitings (Lambert and Marx 1989: 88).

The most common form encountered today is the 'drop dolly', a hollow, tear-shaped spiral, with ears left hanging at the bottom, and a loop at the top for hanging. More complex basic straw plaits include the Border Fan, from the borderlands of England and Wales, made from twenty-one straws, and the Welsh Long Fan, made from seventeen.

In Ireland, St Bridget's Crosses take various forms, though the four-branched one is considered the standard form. Traditionally, they are made on St Bridget's eve, the last day of January. They are said to protect the house and livestock from fire and ill happenings (Evans 1957: 268–70). A three-branched version is used for protecting byres. Crosses containing straw or rush squares related to the pattern called *Godsoog* ('God's eye') in Dutch knitting attached to crossed sticks are also called St Bridget's Cross. In County Galway, residents put crosses of the same pattern in their house rafters at Hallowe'en (Evans 1957: 268).

Straw shoes have already appeared in connexion with Shrovetide traditions. The straw man, once known in England as Jack Straw, or Jack o' Lent, appears on windowsills in south Germany during shrovetide to this day. Breugel's painting, *The Battle of Carnival and Lent* (1559) has a clothed stuffed straw figure sitting on just such a ledge. Winter customs performed at Whittlesey in England and Wilflingen and Walldürrn in Germany, involve a man dressed in straw as the 'Straw Bear', who is led or driven through the streets.

Roofing with Wooden Shingles

Wooden shingles are a traditional alternative to thatch. They are more prevalent in regions where wood is plentiful. Their form resembles the scales of fir cones, overlapping one another to create a waterproof surface. Being small in comparison with the size of the roof, shingles can be set on curving surfaces without loss of waterproofing. Being wooden, they are relatively light, and are most favoured in climates where snow is present for a significant part of the year. Customarily, they are fixed with wooden nails. Traditional shingles are masterly instances of the understanding of natural forces. They are fashioned precisely and arranged so that water will run off in the most efficient manner without penetrating beneath.

Several Norwegian stave churches retain their medieval shingles (fig. 23). As well as covering the roofs, they are also attached to

Figure 23. Norwegian shingle patterns,
from medieval stave churches.

Top row, left: Borgund. *Top row, right:* Fjære.
Second row, left: Bø. *Second row, right:* Eggedal.
Third row, left: Fjære. *Third row, right:* Råde.
Bottom row, centre: shingled pillar, Eidsborg stave church.
Bottom row, others: Various forms of Norwegian shingles,
with carved ends to direct rainwater or melting snow on to
the centre of the shingle below.

walls and posts. The *reginnaglar* ('god's nails') on the high-seat pillars in Norse temples may have been those used to fix shingles to them, as in later stave churches. Probably the Slavonic temples were also shingled. Schuldt's reconstruction of the ninth century temple at Gross-Radern, Mecklenburg shows it with a shingled roof (Schuldt 1976). The medieval Norse and later Finnish, Hungarian, Polish, Romanian and Russian carpenters also attached shingles to curved surfaces, with perfect spacing, creating the appearance of scales. Some of the eighteenth century Baroque timber churches in Russia have 'onion domes' covered with shingles that include rectangular, 'beaver-tail', tapered and serrated forms.

Figure 24. Ornamentally cut slates, echoing wooden shingle design, cladding the wall of a timber frame house in Exeter, Devon.

The general term in France for a shingle is *bardeau*. These have regional names that also describe particular kinds of shingle used there (Walshe and Miller 1992: 156). In the northern Alps, small rectangular shingles are called *tavaillons*. Small buildings in the Jura are traditionally clad in these, and roofed with longer shingles called *anselles*. Also in the French alps, larch and spruce are split to make larger shingles called *essendoles*. They are made from trees that grow on shaded mountainsides, which, having grown more slowly, producing a finer grain to the wood

(Walshe and Miller 1992: 26). Trees for *essendoles* are felled in the last quarter of November on a frost-free day (Walshe and Miller 1992: 88). *Essendoles* keep the snow from sliding off the roof. They will last for upwards of a century, if turned at mid-life. In central Europe, roof shingles on large roofs are kept in place by longitudinal strips of wood, which serve as retainers for large stones. A farmhouse called *Peterhaus* reconstructed in the Salzburger Freilichtmuseum (Austria) has such a roof. In Britain, shingles are much less plentiful. Oak shingles were used to roof the outer part of the stage of the Rose Theatre, Southwark (1592). One, excavated in 1989, is on view in the Museum of London. But the tradition is not dead. Bus shelters erected in parts of northern Derbyshire in 2001 had shingled roofs.

Stone Flags, Slates and Tiles

Thin stone flags and slates are long lasting roofing materials. Stone flags, split from suitable materials, are not so convenient as slates, but where available locally, were favoured. In France, stone roof tiles made of limestone, sandstone or schists are called *lauzes* or *laves*. Traditionally, they are used on low-pitched roofs, where their weight alone is relied upon to hold them in place. The heavy timbers of snow-resisting Alpine roofs have enough strength to support thick stone *lauzes*. In the Dordogne and Provence, the tradition of building corbelled stone houses was continued in structures where the roofing stones are self-supporting. Stone flags in Britain are fitted to the roof by wooden pegs or sheep's bones (Brunskill 1987: 89). Stamford in Lincolnshire is particularly noted for its fine stone flagged roofs.

Slate splits naturally into thin sheets, making it more readily worked than other kinds of stone. Although it is relatively easy to work the material, a high level of skill is needed to make consistently regular slates. In Scotland, at the Ballachulish slate quarry, men served a seven year apprenticeship before being fully qualified to split and dress slates (Cooper 1994: 62–3). Slates are mainly used in roofing, but sometimes they are used to clad vertical surfaces of timber frame buildings, when they may be cut to resemble shingles (fig. 24). The Cornish name for slate, 'hellingstone', tells of its use in covering or 'heling' roofs.

In north Wales and Brittany, where the best slate can be found, slates for roofing were produced in places where it was accessible. The vast Welsh quarries of Dinorwic and Penrhyn date from at least the fifteenth century. In 1557, there were only two kinds of slate produced at Penrhyn, Singles (5 by 10 inches}, and Doubles (6 by 12 inches). As the market for slates expanded, so the range of sizes was widened. In 1738, General Warburton, joint owner of the Penrhyn Estate set up a classification scheme that started with Singles and Doubles. Slates were seen as feminine, for he added Countesses, Duchesses, Marquesses and Queens (Turner 1975: 28). Sized slates were sold by the *mille* (1200), and other larger or smaller slates, called Ton Slates, by weight (Turner 1975: 29). The sizes and range of sizes was developed so that there would be as little wastage as possible in making them from the raw material. With the coming of cheap transport by rail, Welsh slates became a popular roofing material all over Britain.

Tiles are made from fired clay. They probably came to Britain with the Romans. Sizes were standardised in southern and south-eastern England in 1477 (Brunskill 1987: 90). The rectangular Plain Tile measures 10½ by 6½ inches by ½ inch thick. This standardised size gradually spread right across England. Later, during the late seventeenth century, pantiles were imported from the Netherlands. In the early eighteenth century, the size was standardised at 13½ by 9½ inches by ½ inch.

Ridge tiles and roof tiles, incised with graffiti or stamped, are an occasional feature of south German tradition. The earliest, rectangular in form, from south German monastic roofs, have been dated at the eleventh to twelfth century, but the *Biberschwanz* (beaver tail) form became common in the fourteenth (Goll 1992: 275–7). In French-speaking countries these types of tiles are called *tuilles écailles* (scale tiles) or *tuiles en queue de castor* (beaver-tail tiles). Most of the known incised tiles called *Feierabendziegel* were made in the eighteenth and nineteenth century. Some of them may be the ceremonial last tile of the tilemakers' working year, which in south Germany ran from 19 March to 16 October. A fine collection is displayed at the Museum für Volkskultur in Württemberg, at Waldenbuch Schloss (Catalogue, Stuttgart 1990, 54). The sigils include crosses, pentagrams, starbursts, X-signs,

horned figures and personal inscriptions (e.g. Roller 1974: figs. 120, 121).

Pantiles reached England and northern France from Flanders, where they had been introduced in the sixteenth century from Spain, when the Low Countries were the Spanish Netherlands. Their origin is remembered in their French name – *panne flamande* (the Flemish Pantile). In the seventeenth century, pantiles were imported to England from the Low Countries, but, by the eighteenth century, centres of local manufacture appeared. A pantile found during the demolition in 1968 of a weatherboarded barn in Bradmore Street, Cambridge, bore the incised date 1738 (personal observation). Ridge tiles in Germany, France and England have human heads, horses and horsemen, birds and cockerel riders.

Doors

Although there are many preserved fragments of ancient buildings, doors and their fittings are amongst the rarest survivals. Original bronze doors remain *in situ* in Rome on the Pantheon (125 CE) and the Temple of Romulus (early fourth century). These are not hinged, but swing on an axis that fits into a socket in the floor and lintel. Wooden doors of this kind are still extant in the preserved village of *bories* (traditional corbelled stone houses) at Gordes in Provence (fig. 25). In other places, hinges from leather have been used for internal doors. Metal hinges of the type used today appear to originate in fittings for things other than doors.

Locks with keys existed in ancient times among the Celts and Romans. Both door locks and padlocks were made. Reconstructions of sophisticated Gallo-Roman locks can be seen in the museum at the Roman farm at Stein, Baden-Württemberg, south Germany. In medieval times, locks gave smiths the opportunity to create exuberant designs both in the lock-plates and internal mechanisms. The great locks of many manors and castles of that period are still in working order. Decorative locksmithing reached its apex in Germany in the renaissance, when locks that covered the entire lids of chests were displays of the locksmiths' skills. The so-called 'Armada' chests, made in Nuremberg and

Figure 25. Doors.
Left: Traditional swivel-post door of boards in a *borie* at Gordes, Provence, France. *Right:* Timber-frame door with ornamental framing, blacksmith-made grille and traditional chain closures. The *Hexenhausla* (witch's cottage), Nuremberg, Germany.

other south German centres between 1600 and 1800 are the epitome of the practice (but the name 'Armada' is yet another inaccurate name given after the date which has stuck). In the industrial revolution, locks became the preserve of precision engineers, and passed from the hands of blacksmiths and locksmiths.

Iron in Building

When smelting of iron was introduced around 500 BCE, it involved heating iron ore with burning charcoal, producing a 'bloom' of iron. The impurities in the iron were then cleaned out by repeated

heating and hammering, producing wrought iron. This material is completely malleable, being ideal for forging intricate shapes. Smiths flatten, bend, stretch, split, twist and weld iron to make the familiar shapes of the wrought iron repertoire.

Iron is a hard material, but its weakness is a tendency to rust. This means that relatively few pieces of ancient iron have survived to the present. In Britain, there is a Celtic firedog that was preserved in a peat bog at Capel Garmon, Wales (c. first century BCE to first century CE, in the National Museum of Wales, Cardiff). It displays the skill of the smith, with loops, knobs and horned animals' heads as finials. The British Museum has a wrought iron window grille from a fourth century Roman villa at Hinton St. Mary, Dorset. It is a rectilinear grid with X-shaped spikes at the crossing-points.

Many churches, cathedrals and a few secular buildings of the medieval period still retain their ornamental door hinges and grilles. The west door of Durham cathedral cloister has twelfth century wrought iron hinges and strapwork. The strapping of heavy wooden chests and door hinges often has patterns hammered in when the iron was hot. Among the most frequent are cross-bars enclosing X-shapes, sometimes accompanied by dots made with a punch. From the medieval period onwards, ornamental locks and lock-plates appear. Those from centres of weapon- and armour-making, such as Nuremberg, are sometimes made of chased steel.

In fourteenth century Europe, the blast furnace was invented. Blown by bellows powered by a water mill, the furnace reached a temperature high enough for the molten iron to absorb carbon from the charcoal fuel. Unlike iron made by the older process, this could be cast in moulds. Cast iron is not the material of the blacksmith, for, once it is taken from the mould, it cannot be hammered or chased. An early application of cast iron was in the arsenals, where the craft of cannon-founding was developed.

In early eighteenth century England, cast iron was first used for railings around 'polite architecture'. Those around St Paul's Cathedral in London (c.1710–14) and the University Senate House in Cambridge (c.1730, re-sited 1789, extended 1792) have shapes that are derived from cannon. The St Paul's railings were cast by Richard Jones. The architect, Sir Christopher Wren, wanted to

use wrought iron railings, but was outvoted by a committee in March 1709 (Tinniswood 2001: 350).

In traditional or vernacular buildings, the use of cast iron is restricted to firebacks and technical devices, such as water pumps. Cast iron firebacks were made to protect the back wall of the chimney from the heat of the fire. The earliest dated examples come from the sixteenth century. A fireback dated 1588, probably from Sussex, is preserved in the Victoria and Albert Museum, London. Surviving examples from Sussex and Surrey are richly patterned, with designs ranging from trees and birds to royal coats-of-arms and Biblical scenes.

Wind Vanes and Weathercocks

Weathercocks are an ancient and decorative way of indicating wind direction, which to those who know local meteorology, denotes the weather. Their precise origin is questionable, but between the ninth and eleventh centuries, there are several weathercocks recorded in various parts of Europe. For instance, Bishop Rampertus of Brescia, Italy, set a bronze one on the church of St Faustino Maggiore in the year 820. The date is known from an inscription on the cock, found when it was taken down in the seventeenth century (Novati 1905: 497). In England, Bishop Swithun set a weathercock on Winchester Cathedral in the year 863 (Wolstan, *De Vita Sancti Swithuni*, 111; St Swithun's Day is the focus of traditional rain-lore). In 925 the monastery of St Gallen in Switzerland had its weathercock stolen by Hungarian invaders who climbed the tower to take it (Ekkehardus of St Gallen, *Casus St Galli*, 82), and, in 965, the gilded cock on the abbey church of St Pierre at Châlon-sur-Sâone in France was blasted by a lightning strike (Martin 1904: 6). The Bayeux Tapestry shows a man setting the weathercock atop Westminster Abbey on its completion in 1065.

Medieval whistling weathercocks, with reeded tubes that make a sound in the wind, are known from Devon. One is still extant, on the church of Ottery St Mary (Mockridge and Mockridge 1990: 35, 57). Made around 1340 from cast bronze, its body incorporates two whistle tubes containing reeds that sound with the notes B and

G. In 1501, a whistling cock existed on the church of St Mary Major in Exeter (Orme 1986: 53). The intensity of the sound made by such cocks can be used to determine wind speed in the manner of the *makelaar* of Netherlandish windmills.

Cocks and simple vanes are not the only things that traditionally indicate the wind's direction. A medieval saying from France tells how we can find lions, eagles, dragons and other images on the top of churches (Martin 1904: 10). The swan appears in parts of Germany, especially East Frisia and the Oldenburg district (Goethe 1971: 7–19). The eight-foot-long dragon on the church of St Mary le Bow in Cheapside, London, is the most notable vane of Sir Christopher Wren's many churches built after the Great Fire of 1666 (Cobb 1948: 60, 64–5). The building accounts of this church show that the mighty dragon was the result of the cooperation of three different crafts. It was carved in wood in autumn 1679 by a mason, Edward Pearce, as a model for copper smith Robert Bird to make it in metal. Finally it was gilded by a painter, Thomas Lane (Cobb 1948: 49). The dragon stands as the high point of vane making. More humble vanes for ecclesiastical and secular uses continue to be designed and wrought by local blacksmiths.

Pot-hooks

The pot-hook, hanger or hake, from which pots and kettles are suspended over the fire, is the focus of significant lore. In German and French tradition, the pot-hook is called *Hausherr* or *maître de la maison* ('Master of the House'), the locus of the house-spirit (Bächtold-Stäubli 1927–42: IV, 1271). Before they were smith-made from iron, pot-hooks were made of a hard wood, according to Irish tradition, from holly (Evans 1957: 68). It was the custom at weddings in the Eifel, Rhineland, Westphalia and Siebenbürgen, for the bride and groom to make a threefold turn around the pot-hook for luck. Where the hearth was against the wall, and it was impossible to go round the pot-hook, the bride was swung at it three times (Bächtold-Stäubli 1927–42: IV, 1274). The form appears in the heraldry of the Holy Roman Empire (e.g. the arms of the von Bidenfeld family (Hessen), Komanski (Silesia), and Schenk von Wetterstetten (Swabia)) (Appulm 1994: 95, 131,

159). In the early twentieth century, the German master typographer Rudolf Koch called this sign 'the wolf's tooth, or hanger' (Koch 1930: 83).

Wall Anchors

Many old brick buildings are bound internally by iron tie rods with external fixings called wall anchors or tie plates, made by specialised 'anchor-smiths'. Most frequently, they run from gable to gable. The most common old wrought iron wall anchors are I-, S- and X-shaped. Occasionally, two pieces of iron were made into S-shapes and centred to make a fylfot. S-shaped wall anchors sometimes have forked ends or are fashioned into the form of a serpent. In shape they often resemble the pot-hook. They frequently bear sigils hammered in by the blacksmith. Less common are wall anchors bearing numbers or letters, assembled to mark the date of construction or the initials of the owner. Wall anchors provided an opportunity for blacksmiths to display their skill. Some take the form of merchants' house-marks, while others are exuberantly decorative.

In the nineteenth century, they were made in the 'Gothic' style, according to the principles of the Arts and Crafts movement and local variants of Art Nouveau. Ornate and symbolic wrought-iron wall anchors were largely superseded in nineteenth century Britain by the circular dished Pattress plates, which had been developed for railway use. They are still being made in the twenty-first century at Newhall Road Works in Sheffield. Wall anchors, especially those of the S- and X-shaped variety, are supposed to ward off lightning or protect the house from fire. Lithuanian tradition asserts that the X-sign wards off lightning and fire (Leather 1912: 15; Trinkunas 1999: 70–1): steel and iron are supposed to ward off dragons in German-speaking countries (Bächtold-Stäubli 1927–42: II, 402).

Other Metalwork

As with everything in the world, the arts and crafts evolve and adapt to changing circumstances. During the industrial revolution, the crafts of the carpenter, the blacksmith and the foundryman

were brought together by the tramroad and railway companies. The first cast iron wheel tyres on a rail vehicle were made in 1731 (Young 1975: 34). Mass production was not the norm in the heyday of the railways. Until well into the twentieth century, even in the largest works, such as at Crewe, Doncaster, Inchicore and Swindon, everything from numberplates to locomotives were custom made by craftsmen who had served their apprenticeship.

Railway foundries used traditional techniques to make 'one off' items for every purpose. Cast iron signs (e.g. Thomas 1975: 54–65), carriage and wagon numberplates and locomotive nameplates were all made by using hand-carved wooden moulds whose impression, left in special casting sand, was filled with molten metal. Small, local, companies, whose finances did not compare with the larger railways, made use of local craftsmen. Although the wheels and running gear were bought in from outside manufacturers, the wooden bodies of railway vans and wagons were often made by local carpenters, and their metal fittings by blacksmiths. The brake van illustrated here, from the Welshpool

Figure 26. Country railway brake van of tongue-and-groove boarding with blacksmith-made fittings, Welshpool and Llanfair Light Railway, Wales, early twentieth century.

and Llanfair Light Railway, dating from around 1902, has blacksmith-made strapping and bolts (fig. 26).

Tramway companies, especially in the days of horse traction, continued local tradition. When local skills were available, they had an influence upon how new things were made. For example, the Spa Road Works was set up in Dublin in 1882 to carry on the local coach building tradition in the construction of horse trams (Corcoran 2000: 28). Thus traditional techniques were kept in being in a changed environment. Close examination of blacksmith-made fittings on old rail vehicles, buildings and tools often reveals craftsmen's marks and the decorative patterns found in contemporary metalwork in more traditional settings. The author has a cold chisel from the Great Eastern Railway workshops at Cambridge (earlier than 1923), with non-functional incised patterns.

Chapter 5
Meaningful Crafts

Signs, Sigils, Symbols, Marks and Mascots
in the Arts and Crafts

Because people are not just separate individuals, but members of particular collective institutions, such as families, guilds, religions and nationalities, when they build or make things they leave some part of their group identity in what they create. This is often more than just the incidental marks of their labour, the style in which they do things, for workers frequently leave deliberate signs in their handwork. They may be invisible, such as coins or bottles embedded in the foundations or beneath plasterwork; they may be visible marks, such as personal craftsmen's signs; or they may be patterns, signs and pictures that are often called 'decoration' or 'ornament'.

In addition, there are those signs commonly associated with love, health or good fortune that, until the second half of the twentieth century, were called 'mascots'. This is a useful description of these things, for unlike the more technical terms of amulet, talisman or apotropaic sign, it denotes something given meaning by the person who deliberately put it there rather than something that has a commonly agreed magical meaning.

Even the discussion of signs that do, on the evidence, appear to have magical and apotropaic meanings is fraught with problems. Certain signs are used in most parts of the world, with varying origins and accepted meanings. For example, apart from any magical significance, the character 'X' stands for at least 11 different phonetic meanings in various western alphabets (Pennick 1992). When discussing a particular identified system (religion, heraldry, alchemy, hallmarks, trades, etc.), then the meaning of signs is given. William R. Lethaby described this as "a code of symbols, accompanied by traditions which explained them" (Lethaby 1892: 2). However, problems arise with the need to identify whether a specific sign have been made within the context

of any given system. Also, whatever the original intent of the maker of the sign, which is often unclear, both the official meaning and customary interpretation may have altered since he or she made it.

Most of the recorded signs ascribed apotropaic or magical powers discussed here are post-medieval. From the late Middle Ages, it is clear that various magic books were circulating among wise women, magicians and cunning men. These are recorded in several countries. In England, there are the books titled *The Devil's Plantation*, *The Infidel's Bible* and *The Secret Granary*; in Germany, *Jerauchia* and *Stamphoras*; (Bächtold-Stäubli 1927–42: VI, 1001). Several Scandinavian texts survive, including *Cyprianus*, the *Galdrabók*, and the *Huld Manuscript* (Davídhsson 1903: 150–67). Magical texts occasionally turn up in protective contexts (e.g. a talismanic script found beneath a brass plate on an old tombstone in a Lancashire churchyard (Dodds 1870: 129–38)). In addition to incantations and magical formulae, they contained sigils and signs which undoubtedly were part of the repertoire of craftspeople. The most common are dealt with below.

Craftsmen's Marks

Because of academic interest in freemasonry, and the durability of the stone in which they were cut, the study of the well-known masons' marks has tended to overshadow the craftsmen's marks of other trades. The commonly-held myth that medieval craftsmen were anonymous has also clouded the study (Harvey 1958: 64–5). The custom of signing work with initials or full names did not appear until the Renaissance, initially on artwork such as wood engravings, and appears to have spread from there. But the tradition of craftsmen's marks did not stop there. It continues today in some circles.

Among the Sheffield knife-makers, a youth was apprenticed by indenture until he was twenty-one. Then, he had to take out his mark and freedom by producing an acceptable piece of work. Then he became a journeyman cutler (Cooper 1994: 50–1). If he eventually attained masterhood, then he could stamp his wares with his own personal mark. This is the common way of working

with marks on work that can be attributed to an individual. In certain places, however, the use of individual signs faded with increasing literacy. In Poland, for example, from the eighteenth century onwards carpenter-builders signed their buildings with their initials, and a six-pointed rosette with the date that appears on the central beam of the main room, or the door lintel (Pokropek 1988: 16).

In addition to craftsmen's marks, and partly overlapping their function, are the house- and holdings-marks used by medieval and later tradesmen, merchants and organisations (Koch 1930: 76–92). According to Koch, these were embroidered on fabrics, punched into timber floated downriver, earmarked into domestic animals, daubed on sheep, clipped in the coats of horses, painted on sacks, carved on fruit trees, ploughed into the surface of fields and cut on sticks used for drawing lots. Drawing marked sticks at random to allocate particular 'lots' of common land (allotments) to villagers is recalled in the Scottish system of 'run-rig'.

The variety of recorded craftsmen's-, house-, and merchants'-marks warns us to bear in mind that signs found upon artefacts that are ascribed an apotropaic function may actually be the marks of individual craftspeople. Particular marks on small artefacts may indicate the date or the city of origin, as in the hallmarks of items made from precious metals (e.g. the compulsory 'workman's mark' and 'the lion and leopard's head crowned' prescribed by *The Goldsmith's Order*, London, 1675). Taken out of context, these marks may be incomprehensible.

Finally, there are the marks and symbols that served as recognition signs for members of particular trades, journeymen's clubs or friendly societies, such as the Oddfellows, the Britons and the Druids. A few of these are well documented, such as the lath bundle as the symbol of unity, or the beehive, representing labour (Leeson 1971: 10–11). Others, especially those whose form was reduced to a few lines, are more opaque in their meaning.

The Holy Corner

In Central European and Scandinavian farmhouse tradition, diagonally opposite the stove is the holy corner, with built-in

benches and the family table. According to Pokropek (Pokropek 1988: 46), archaeological studies in Poland show this to be a pre-Christian room division. Russian tradition teaches that one must not sleep in the path of the *Domovoi*, (the house spirit), near the threshold, in the centre of the floor, or by the stove (Linda J. Ivanits, *Russian Folk Belief*, 54). The rectangular or parallel system of room-division is more recent. In Poland and Scandinavia, the old tradition was gradually overtaken by the newer one between the seventeenth and twentieth centuries (Nodermann 1988: 328).

In Sweden the diagonal arrangement appears to have been abandoned when standardised factory-made tables were used in preference to those custom-made by local carpenters. The later introduction of the television set had a similar effect in effecting a major reorganisation of the internal arrangement of pieces of furniture in rooms.

In Catholic south Germany and Austria, the diagonal tradition is maintained in the twenty-first century. The *Herrgottswinkel* or *Herrgottseck* (Lord God's corner) or *heilige Hinterecke* (holy back corner) traditionally takes the form of a wooden shrine, built into the fabric of the house in the corner of the living room (e.g. Kossmann and Hummel 1906: figs. 27a, 27b). In it are set holy images, religious texts, crosses and offerings. The salt and pepper are kept in a cupboard beneath the niche. In more modern houses, a crucifix is attached to the corresponding ceiling corner.

Threshold and Hearthstone Patterns

There are traditions from various parts of England, Cornwall, the Isle of Man, the Isle of Lewis and mainland Scotland of making temporary patterns on the threshold or hearthstone for good luck. M.M. Banks tells of dairy floor designs in Ayrshire, carefully traced afresh each morning (Banks 1935: 78), and of a Tweedside cottage which had designs on the threshold, round the hearth and on the floor along the living-room walls. In Devon, H. Fulford Williams reports that 'certain old women' would draw elaborate patterns on the thresholds of cottages 'to keep out the Devil' (Williams 1951: 77).

Figure 27. *Top:* Cobble paving, with protective cross.
Welshpool, Powys, Wales.
Bottom: Walling of tiles and brick, with 'tree of life'
pattern, c.1925. Cambridge.

In Scotland, the West Country, Cheshire and East Anglia, they may be drawn with chalk, pipeclay or sand (Canney 1926: 13). In Eaton-under-Heywood in Shropshire, patterns were 'laid' on threshholds, stone steps leading to bedrooms and the hearthstone, where they were said 'to stop the Devil coming down the chimney'. They were created by rubbing bunches of elder, or sometimes dock or oak leaves on the stone. Continuous looping patterns were made in a single sweep, without taking the hand away (Dakers 1991: 169–70). The continuous patterns are the same as the 'running eight' used in Newmarket and Cambridge. There is a pattern seemingly local to the city of Cambridge, called the Cambridge Box (personal observation). Ella Mary Leather records doorsteps in the Herefordshire villages of Dilwyn and Weobley having a chalked 'box' containing nine crosses, but she does not show how they were arranged (Leather 1912: 53). Borders of crosses within two lines are reported from Shropshire (Hayward 1938: 236).

Other patterns recorded from Scotland include all-over diaper work, X and double-X, overlapping circles, spirals, fourfold patterns, eight-petalled flowers, looped corners and trees (Banks 1935: 78–9). The horseshoe and the national emblem of the thistle also appears (with the suggestion that prickly plants were sometimes used to ward off witchcraft) (Pennick, A. 1978: 14.). A

Figure 28. British threshold and hearthstone patterns.

Top row, left to right: The 'Cambridge Box' doorstep pattern, Cambridgeshire; Ayrshire doorstep pattern; Lanarkshire milk-house flagstone design.
Second row, left to right: Lanarkshire door-step; Lanarkshire milk-house and dairy pattern; Craigie, Ayrshire, doorstep.
Third row, left to right: Lanarkshire hearthstone; Lanarkshire doorstep; Soudley, Shropshire, step design.
Fourth row, left to right: Craigie doorstep; Ayrshire border pattern; Lanarkshire dairy pattern.
Fifth row, left to right: Ticklerton, Shropshire, step pattern; Stirlingshire hearthstone.
Sixth row, left to right: Border patterns from Ayrshire, Cambridgeshire, Lanarkshire, Shropshire and Stirlingshire.

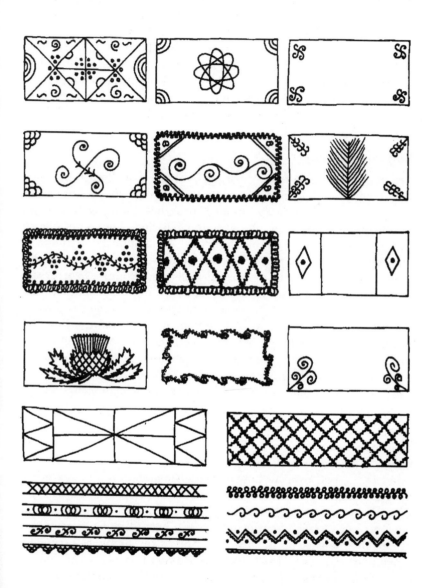

Shropshire pattern involves an eightfold cross (fig. 28) (Hayward 1938: 236). Three separate circles are the traditional hearthstone pattern at the Fleece Inn in Bretforton. Many of these designs appear also in East Anglian pargetting. These temporary floor patterns may be reflected by the permanent patterns found in flooring made from bones, cobbles, bricks and tiles, such as the bow-lines in the pebble paving in front of windows and doors of old houses in Llanidloes, or crosses in other Welsh towns (fig. 27).

Building Deposits

Traditions recorded from most parts of the world tell how when beginning a building, people put offerings or deposits into the earth along with the foundation stone. These are things that are not necessary structural members of the building, but items placed there deliberately by the builders. In buildings without a foundation stone, deposits are secreted beneath the threshold, underneath the sills, in cavities in walls and chimneys, or in the roof. The meaning of these deposits is often unclear. Ritual placement of body parts of dead holy men and women is part of the foundation ceremonial of Christian places of worship in the Roman Catholic tradition, but this is restricted to sacred buildings. In the secular context, common deposits include animal remains, coins, bottles and jars, shoes, old tools and occasionally an object from which a symbolic or magical purpose may be determined.

One such recurrent building deposit is a round-bellied stoneware vessel, salt-glazed with a brown or grey finish, imprinted with a bearded human face and often a decorative or heraldic roundel beneath it. There may be other stellate or punctate stamps on other parts, and overall, they are unmistakable. First produced in the Rhineland around 1500, their manufacture spread through the Low Countries to England, and production ceased around the beginning of the eighteenth century. In England, these vessels are called Greybeards or Bellarmines, the latter name referring to Cardinal Bellarmine (1542–1621), a Roman Catholic inquisitor in the Low Countries during the religious turmoil of the period. Like many such artefacts, the name was not applied to them until later (William Cartwright, in his play *The Armoury*, 1634).

The numerous magical uses of these and similar vessels does not concern us here. Where they are relevant is in building, where they have been found beneath the threshold and the hearth. There have been many finds, in mainland Europe as well as Great Britain. The following are a few characteristic examples. Jugs have been found beneath hearths in various Suffolk locations, including the Duke's Head public house at Coddenham, the former Shoulder of Mutton Inn at Stratford St Mary, and houses at Needham Market (Owles and Smedley 1968: 80–1), Stradbroke and Great Wratting (Bunn 1982: 3–7). A.G. De Bruyn reports a Siegburg jug buried beneath the threshold of a house in Oldenburg, the Netherlands (de Bruyn 1929: 12–16), while another was found at Baardwijk (Essink 1953: 109–10). A pot containing bird bones, coins and earth was found behind an oven in Möttlingen, Germany (Kiesewetter 1893: 254–5).

The idea of the connection between such pots and the continuance of a building is present in Ariosto's *Orlando Furioso*, Canto IV, where a magic castle is destroyed when pots beneath the doorstep are broken. Large numbers of shoes, bones and mummified cats have turned up in chimney breasts and on top of walls or wall plates beneath the roof. Other items are occasionally retrieved from beneath the threshold, over door lintels or beneath windowsills (e.g. a 1904 lemonade bottle, Bromley, Kent (Brennan 1985)). Many of these items were clearly put there during building works. Items placed in buildings once they were complete (commonly bottles and pin-stuck hearts up chimneys, e.g. a bullock's heart at Marshwood, Dorset, (Lang 1969: 222–3)) need not detain us here.

The Heart Sign

The heart is commonly thought of as a universal mascot of love. In the carvings at Edzell Castle, near Brechin, Scotland (1604), for example, the goddess Venus is shown holding a flaming heart. This image was copied from engravings by the Nuremberg master Jörg Bentz made in 1528–9 (Simpson 1933: 17–24). But as a sign in the arts and crafts, its meaning may be much more problematical. What appears to be a heart sign now may not have originally been one. For instance, the hearts that compose the

arms of the kings of Frisia, first shown in a Parisian armorial of 1528, seem to have been waterlily-leaves in earlier Frisian heraldic devices that were transformed into hearts by the sixteenth century (Fryske Akademy 1956: 62). Two of the earliest English horse brasses, of 1776 and 1778, are in the form of hearts (Brears 1981: 13–14).

Pig and cattle hearts, often stuck with pins and thorns, have been discovered in house chimneys in various parts of England (London, Cambridgeshire, Dorset (Rushen 1984: 35; Brian Hoggard, personal communication)). One explanation is that they were used for a magical cure of cattle (March 1899: 483; Dacombe 1935: 109–10).

A.J. Lewery notes that in the early twentieth century when sailors were beginning a voyage, they were often given a lucky charm against storms that consisted of a heart-shaped pincushion stuck full of round-headed pins in various ornamental patterns (E.D. Longman and S. Loch, *Pins and Pincushions*, 1911, cited in Lewery 1991: 104). A cloth heart with brass pins was found in an earlier 'witch bottle' at Ipswich (Bunn 1982: 4). The sign of the nailsmiths in Alsfeld, Germany, shows a heart penetrated by three nails (Peesch 1983: 111), a Christian image that leads to the possibility that certain images of hearts in folk art, where not obviously personal love is involved, may refer to the cult of the Sacred Heart of Jesus. Oliver Cromwell's puritan chaplain, Thomas Goodwin, in his *Opuscula*, (Heidelberg, 1658), wrote on *Cor Christi*, the heart of Jesus. In 1675, at the monastery of Paray-le-Monial, a Catholic nun, later canonised as St Marguerite Marie, originated the devotion to the Sacred Heart of Jesus (de Givry 1973: 217). The heart appears in various ways in emblem books and alchemical illustrations, such as the *Musaeum Hermeticum reformatum...*, (Frankfurt 1678, 420). The symbols of the Parisian alchemist Nicolas Flamel show a 'divine heart' from which emanates a flower or plant, surrounded by a garland of thorns (L'Agneau 1636). It appears sometimes in Bavaria with a cross (fig. 13).

Decorative or Symbolic Patterns

Materials that naturally have a repetitive structure, such as weaving, knitting, tile- and brick-work, lend themselves to the creation of distinct patterns. These patterns, which are used widely, and occur in other media, such as metalwork, pottery and woodwork, can have no single meaning. When we search for meaning, there always seems to be a number of explanations that often vary from place to place. This is because traditional culture is nowhere static and subject to central authority. Every place has its own local traditions, and the meaning of patterns is part of them. They have a remarkable tenacity, having been handed on from generation to generation over great swathes of time, occurring in many different places. What the connection is between each one, other than being another instance of the pattern, is a bewilderingly complex matter. The blanket term 'apotropaic', evil-averting, is frequently given to these patterns by folklorists. But without historic precedent in each case this is just another taxonomic description, not an explanation of its meaning. Even commonly held explanations may have originated in published speculation in folklore journals and popular books.

The five-lozenge pattern called *Godsoog* (God's Eye) in parts of Holland is held to signify the overseeing eye of God. In County Galway, Ireland, the pattern is used for wood or straw crosses put in the roof rafters at Hallowe'en (Evans 1957: 268). Knitted into fishermen's sweaters it is said to look after men in strange ports so that they will behave themselves (from an informant in IJmuiden; van der Klift-Tellingen 1987: 19). At Urk, once an island in the former Zuider Zee, the same pattern is called the 'flower', while in its single form in the British Isles, it is commonly called the 'diamond'. On Eriskay, in the Outer Hebrides, it appears in association with the X-pattern, as the 'cross and diamond' (Starmore and Matheson 1983: 36). Continuous lozenges are used as the 'fishnet' on Dutch sweaters from Arnemuiden, where the pattern appears in the brickwork of traditional houses (van der Klift-Tellingen 1987: 22). To Dutch knitters, the zigzag is called variously 'lightning bolt', 'marriage lines' or 'snake', the latter serving as a warning to 'prowling evil' (van der Klift-

Tellingen 1987: 21). On brickwork in East Anglia, it is said to ward off lightning.

The traditional style of pottery painting from the borderlands of Germany and Poland called Bunzlau or Boleslawiec is characteristically covered all over with repeated concentric circles around central dots. The outermost circles are always blue. In Germany, this pattern is known as *Pfauenaugen* (Peacock's (feather) eyes). It is a pattern that occurs on much more ancient artefacts, especially of bone, such as combs, and upon wooden furniture, such as clothes chests.

The X Sign

The sign of X, sometimes referred to as a 'St Andrew's Cross', but without any apparent reference to the saint, appears frequently at entrances. An East Anglian tradition asserts that a brick inscribed with an X above a door will avert evil (I have been told this a number of times by various local informants). The most celebrated use of the X is upon so-called 'witch-posts'. The name 'witch-post' is actually not at all ancient. Its first recorded use was in 1936, when a heck-post or speer-post from Egton was presented to the Whitby Museum (Hayes and Rutter 1972: 87). Two such heck-posts, from Scarborough and Danby, were donated to the Pitt-Rivers Museum by Canon Atkinson of Danby in 1870 and 1893, and they were not described as 'witch-posts' then. There is no mention of the term 'witch-post' in Canon Atkinson's writings on local lore (Hayes and Rutter 1972: 87), so it appears to be a twentieth century term (fig. 29).

The date 1664 appears on one at Postgate Farm, Glaisdale, in a building dating from 1784. It bears the initials EPIB (Elizabeth Pruddon and John Brackon) (Hayes and Rutter 1972: 93). Only

Figure 29. Carved speer-posts and *Stiepel*.

Top row, left to right: Speer-posts from Yorkshire: Rosedale, Gillamoor, Farndale, Glaisdale, Scarborough.
Middle row: Two speer-posts from Danby.
Bottom row, left to right: Silpho and Glaisdale, Yorks., Nammen and Lerbeek (both near Minden, Germany), Egton, Yorks.

one such post is known outside north-east Yorkshire, at New House, Rawtenstall, Lancashire (Hayes and Rutter 1972: 87). Bugle Cottage at Egton was rebuilt in 1927 with a new heck-post, said to be made of Rowan wood, copied from an older one (Hayes and Rutter 1972: 89). A heck-post from Low Bell End has second cross incised in the nineteenth century by a cunning man known as 'The Wise Man of Stokesly' (Hayes and Rutter 1972: 93).

Hipknobs known as *Geck* or *Geck-Paol* with three-dimensional X-carvings on four sides of the post, and sometimes supporting a wooden 'egg', are known from Ravensburg and Osnabrück in the the former Dukedom of Minden in north Germany (Wirth 1934: VI, 572, pl. 268., fig. 3). There is a very similar sign known as *steepelteeken* in the Ostmarsum region of Twente province of the Netherlands (Propping 1935: 143) and *Stiepel* in the Minden area of Lower Saxony (Wirth 1934: VI, 572, pl. 269, fig. 1). It is an incised sigil usually of two equilateral triangles apex-to-apex, located on the posts of farm doors.

Alternatively, there may be a crossbar, dividing the field into six. This pattern, made of sticks, is called *Schratterlgatterl* or *Schratlgaderl* in the Bavarian Alps, the Austrian Tyrol and the South Tyrol (Italy). It serves as a 'blocker' to close paths to humans and to banish harm (personal observations 1992–7). An example of this recorded by Propping carved on a house in Wietersheim-an-der-Weser was painted green, blue and white (Propping 1935: 145). One was incised at the Teut-Hof at Hiddersen near Detmold, a building dated from 1573, whilst another building with the sign at Frille was dated 1788 (Weiser-Aal 1947: 146). This sign may be seen painted on a much larger scale on shutters of buildings in Holland, Frisia and North Germany, and at the centre of the sails of Dutch windmills; signs like this appear on Norwegian wooden utensils and vessels (Weiser-Aal 1947: 143).

Today rune enthusiasts refer to this pattern as the *Dag* sign, a name given to it by Walter Propping in 1935. Propping's authority for this was Hermann Wirth, whose highly speculative work was popular during the National Socialist era (Wirth 1934: I, 56; VI, 556–73: Propping 1935: 144). Wirth calls the sign *Tag* (day) and connects it with the 'double axe'. Wirth's examples are extensive, but his ideologically-driven interpretations are dubious. Another

follower of Wirth, Oskar von Zaborsky, illustrates a lych-gate at Eventin, Kreis Köslin, with the sign inscribed on both pillars. Without explanation, he describes its meaning as 'the wish for rebirth' (Von Zaborsky 1936: 114–5, fig. 244).

The X-form appears frequently on blacksmiths' work on doors and window-fastenings. In Lithuania, it is associated with warding off lightning and fire (as the symbol of Perkunas, god of fire (Trinkunas, 1999: 70–1)). It can be found from medieval times into the twentieth century, and was favoured by Arts and Crafts architects like Mackay Hugh Baillie Scott (Haigh 1995: 79). The related sign of the upright cross is the primary Christian symbol, and it occurs frequently in buildings.

Clearly related to these signs are the painted chequer or lozenge patterns which were the sign of a public house in England. Surviving illustrations show that they were frequently painted on the diagonal. William Hogarth's engraving *Beer Street* shows the sign. One origin theory claims that it originated as a representation of a merchant's or money-changer's 'abacus', which then came to indicate an inn or house of entertainment (Larwood and Hotten 1985: 294). Another idea is that some public houses called the Chequers took their name from the custom of painting signposts with alternate black and white squares (Monson-Fitzjohn 1926: 45). One of the last ancient survivors of this tradition was at *The Methuen Arms* in Corsham, Wiltshire (Keverne 1955: 24, 91, 92). Also connected with brewing is the star of six rays, with the outer arms of the upper part shorter than the central one. When this sign is seen on a building, it might represent the brewers' 'sparger', an implement used to distribute liquor over malt or grain in a mash-tub. A token issued by William Tanner, brewer, of Ely, Cambridgeshire, c.1650 to 1690, has such a sign (Holmes and Blakeman 1983: 11).

Interlacing Patterns

Traditionally, interlacing patterns serve to bind up bad luck and the cause of bad luck. They appear in Roman mosaics and post-Roman artefacts and architecture including Irish illuminated manuscripts, Celtic and Anglo-Saxon crosses, Alamannic, Norse

and Lombardic art. The most basic knot, the four-fold loop, is known from a memorial stone on the island of Gotland (Havor II, Habingo Parish, between 400–600 CE) (Nylén and Lamm 1981: 39), bracteates from Denmark (Wirth 1934: VIII, pl. 424, fig. 1b; pl. 427, fig 7b) and on Romanesque capitals in Quedlinburg Cathedral (Wirth 1934: pl. 429, fig. 3). The basic form also occurs in Lombardic art (e.g. at Cividale (Petrie 1930: pl. XLI, B3)). Along with more complex versions, it is called *Sankt Hans Vapen* in Sweden and Swedish-influenced Finland (Strygell 1974: 46), simple versions of it, the *Hannunvaakuna*, are used in Finnish timber frame buildings and in Estonia. Versions of this sign appear in medieval graffiti in Britain and Scandinavia, e.g. at Cowlinge, Suffolk (Pritchard 1967: 133).

With a central cross-loop, it occurs in English clog almanacs, marking All Saints' Day, November 1 (e.g. the Ashmolean Clogs B and C (Schnippel 1926: pls. II, III)). Because of this, it is used by contemporary Pagans as the sigil for Samhain (Hallowe'en) (Pennick 1990: 35, figs. 8, 13, 26, 35). A variant of this, from a wooden vessel from Setesdal, Norway, was described as a *Valknute* in 1947 (Weiser-Aal 1947: 126). However, the name *Valknute* is frequently used to describe a figure made from three interlacing equilateral triangles (the 'knot of the slain', sometimes spelt 'valknut' or 'valknutr'). Because of its appearance on some Gotland memorial stones, to-day it is connected with the god Woden/Odin (*vide* Thorsson 1984: 107 Aswynn 1988: 153–4. A simpler version of this sign, a triangle with a superimposed cross, is called 'St Bengts Vapen' (Strygell 1974: 46).

Composed of compass scribings, the six-pointed rosette appears frequently on traditional vessels in Norway (Weiser-Aal 1947: 117–144), commonly called 'St Olaf's Ros' (Strygell 1947: 46). In Poland, carpenters signed their buildings with their initials, and a six-pointed rosette with the date. This appears on the central beam of the main room, or the door lintel (Pokropek 1988: 16). Closely related to these patterns is the Christian monogram IHS (for *Iesus Hominem Salvator* – Jesus, saviour of men), frequently composed of interlaced letters and used as an amulet (e.g. Hammarstedt 1920: fig.107).

The five-pointed figure called the pentagram is a form of interlace pattern drawn with a single stroke. It appears in folk art in various parts of Europe as a protective sign (in German, called the *Drudenfuss*), both as visible carvings or paintings, as horse-brasses, and as hidden scratch-marks on treen, pottery or tiles. It is also used as a craftsman's mark in both masonry and metalworking, as well as in overt magic 'for good luck's sake' (John Aubrey, cited in Stevenson 1984: 417). Reinhard Peesch writes that in folk art these five-, six- or eight-pointed interlacing 'pentacles' are always used with an apotropaic function, on babies' cradles, bed-boards, salt-containers, etc. (Peesch 1983: 75).

The Tree of Life

The pattern commonly called the Tree of Life was traditional on slipware milk jugs in Vojvodina (Pantelic 1984: fig.140) and England (Kent, 1659; Essex, mid-seventeenth century, Fitzwilliam Museum, Cambridge), Dutch and Aran sweaters, German *blaudruck* printed fabrics and Scottish hearthstone designs. (A Thüringian example, probably nineteenth century, is illustrated in von Zaborsky 1936: fig. 168.) It appears in Central European wrought-iron grilles from the medieval period onwards. It was popular among architects in the late 1920s and 1930s in brick- and tile-work (fig. 29), and particularly for the metalwork of glazed doors in cinemas and office buildings.

The Horseshoe

The proper place for an old horseshoe appears to be nailed on or above a door or window, or on the mast of a ship. It is universally regarded as a mascot of good fortune. A common principle is that the horseshoe should be nailed up with its 'horns' upwards. To put it the other way is to let the luck run out (e.g. Villiers 1923: 92). In *The Folklore of Hereford and Worcester* Roy Palmer associates the 'points up' horseshoe with the moon, and the 'points down' one with the Greek character *Omega* (Palmer 1992: 109). In Polish heraldry, the horsehoe appears horns up in the arms of Jastrzbiec-Bolesta, an emblem shared by more than 550 families (von Volborth 1981: 125, fig. 766).

In Herefordshire, the horseshoe appears to have been considered an inadequate protection against bewitchment without a rowan or elder stick with nine notches accompanying it over the door (Leather 1912: 53). The much less common round horseshoe form, still used in Northumberland in the early twentieth century, and 'especially prised as a bringer of luck' (Johnson 1912: 426–427), appears as a pargetting pattern in parts of Essex (e.g. The Old Sun Inn, Saffron Walden).

Writing in 1894, George Day stated, 'At Ilford, I saw a horse-shoe nailed to the door of a cow-house, and on asking a lad the reason, he replied, "Why, to keep the wild horse away, to be sure"' (Day 1894: 77). I may have experienced traces of this tradition in Chatteris, Cambridgeshire. When I was guising as a horse with the Northstow Mummers in 2000, a group of boys ran away from me, shouting, in mock terror, 'It's the horse of death!'.

Traditional Identification and Trademarks

Patterns have been used as means of identification. The patterns on fishermen's sweaters frequently identified the origin-place of the man. Pilgrims to Jerusalem were tattooed with crosses and various other designs, as were Christian women in nineteenth century Bosnia (Helm 1995: 15–21). Such pilgrims' tattoos may have introduced their motifs into new areas where they were taken up in other media. In Britain, the silks of jockeys in horse racing bear identifying marks such as diamonds, stripes and spots, whose origins lie in the eighteenth century.

Readily recognisable images and colours are among the earliest trade and identification marks. The red triangle of Bass breweries and the blue star of Newcastle Brown are in the same vein as those of the early railway companies, such as the quatrefoil of the North British Railway and the 'Egyptian Diamond' of the London and North Western. In the early part of the last century, tram routes in Dublin were distinguished by coloured emblems, such as a white square, red triangle, green shamrock and brown lozenge (Corcoran 2000: 62–3). The trams running today in Sheffield denote their routes by different coloured squares, as the earlier system (1873 to 1960), never carried route numbers.

There are few records of the reasons why these signs were adopted. According to a masonic writer, Clement E. Stretton (Stretton 1980: 14), 'In 1836 Mr Joseph Locke, the engineer of the Grand Junction Railway, decided to have a "Trade Mark", so that Grand Junction trains could be distinguished from those of other companies. Mr Locke at that time was a member of the guild or company of Freemasons by whom the ancient diamond of Egypt was preserved, and he decided to adopt it'. Locke had it painted on locomotive buffer-beams and tank backs, and on all vehicles belonging to the company. Thus, according to Stretton, a masonic symbol became a trade mark. This is the sort of craftsmen's continuity that can exist in the most unexpected places.

Afterword

Continuity and Continuing Relevance

Building in the Arts and Crafts Movement

In Britain, the Victorian period's exuberant architectural eclecticism set off a reaction that has been called 'vernacular revival' (Brunskill 1987: 210). The artist-craftsmen whose houses are thus called sought to bring into their work an authenticity that they found lacking in eclecticism. So they looked to what was most characteristic of their regions and then created contemporary reinterpretations that embodied the essence of the tradition. They saw their work as carrying forward traditional culture, for the description of something as a 'revival' devalues the progressive continuity that is the essence of craftsmanship. In the best of the Arts and Crafts, innovative creativity is expressed within tradition. One of the key tenets of the Arts and Crafts movement was to encourage mindfulness in place of the careless way of working that had caused the decline of crafts in the nineteenth century.

Mackay Hugh Baillie Scott noted that the art of building is undermined in by what he called the 'mechanical ideal' of regularity and smoothness that devalues the part played in construction by the craftsmen. The work of a craftsperson is literally personal. Conscious attempts to erase the mark of the craftsperson's hand is literally depersonalizing to the artefact, resulting in the fault of faultlessness. The designers of Arts and Crafts architecture and related artefacts learnt from continuing local tradition both through studying extant buildings and from local craftsmen (e.g. Nicolay Nicolayson's study travels in Scandinavia between 1881 and 1891, and those of Yrjö Blomstedt and Victor Sucksdorff in Russian Karelia (1894) were fundamental to the Finnish national arts and crafts movement (Wäre 1991: 34, 226)).

Symbolic traditions, too, were a significant element. Influential here was William Richard Lethaby, through *Architecture, Mysticism and Myth*, London, 1891, his built works (1891–1902), and, from 1896, his teaching at the Central School of Arts and Crafts in London. Baillie Scott used extensive traditional timber framing in his larger commissions (e.g. Blackwell at Bowness, 1898–9 and Tanglewood, Letchworth Garden City, 1906–7), as did Edwin Lutyens in his earlier works in Surrey, such as Fulbrook, near Elstead, 1897, and Orchards near Godalming, 1899.

In mainland Europe, too, following British influence, the same themes were current, leading architects of their day using craftsman-made timber framing in their buildings. Among them were Henry van der Velde, with the Villa Bloemenwerf, Brussels 1894–5; Josef Hoffmann and Robert Oerley in Vienna (Borsi and Godoli 1985: 93, 96–7). Between 1900 and 1902, Hoffmann worked with the traditional *baumeister* Franz Krasny for the houses of Moll, Moser and von Spitzer. Oerley's Villa Paulick was influenced by the work of the English Arts and Crafts movement architect Charles Annesley Voysey.

In 1906, Baillie Scott wrote that although a house should be convenient and aptly fitted to its material functions, it has a certain poverty if it does not also express something of the aspirations of the spirit of its builders. A house should possess, asserted Baillie Scott, a soul of its own (Baillie Scott 1906: 73–5). It is the successful enabling of this soul to come into being that is the crowning achievement in the Arts and Crafts movement. To this end, the Cotswold buildings designed by Ernest Barnsley, most particularly Rodmarton Manor (1909–26), were made by local craftsmen who were enabled to produce their best work within their own tradition (Brill 1987: 37–9).

The Norfolk flint houses of E.S. Prior and the Lancashire traditions of Edgar Wood are other exemplars (Brunskill 1987: 211). Wood's later work with decorative brickwork and curved surfaces (e.g. Upmeads at Stafford, 1908) appears to have influenced the craft-based Amsterdamse School (1913–40). The recessed façade of Upmeads is reflected in the corner treatment of the De Dageraad housing society apartment building at P.L. Taakstraat, Burgermeester Tellegenstraat, Amsterdam, designed by Michel de

Klerk and Piet Kramer (1918–23), which was itself a major influence on 'Art Deco' architecture in brick.

Arts and Crafts Movement buildings were designed to blend with the landscape both by the use of local materials, and through their siting. William Lethaby recognised and taught the subtle relationship of building with the land in both the western and eastern traditions. It is notable that E.J. Eitel's 1873 work *Feng-Shui, or The Rudiments of Natural Science in China* is in the bibliography of Lethaby's *Architecture, Nature and Magic* (1956), a posthumously published collected work of articles serialised in *The Builder* in 1928.

The studies made by Arts and Crafts designers came at a time when every aspect of traditional craftsmanship was still practised. From master craftsmen, the architects learnt techniques that they realised could be applied as novel solutions to constructional problems. These, taken largely from wagon-making and traditional farm implements, they applied in both furniture and buildings. Some of Sidney Barnsley's Cotswold furniture used wainwrights' techniques (e.g. an oak coffer with wagon framing (Comino 1982: 174)). A Barnsley table for Rodmarton Manor used 'hayrake stretchers' whose design came from the traditional 'heel rake' used in haymaking (Comino 1982: 119, fig. 88). In the late 1920s another Cotswold craftsman, Peter Waals, made a ceremonial table in oak for Leicester University College using hayrake stretchers. The craft of the wainwright also probably provided the inspiration for Charles Rennie Mackintosh's painted uprights in the library of the Glasgow School of Art (1907–9), where he used wagon chamfering (though similar work exists in a few Frankish *fachwerk* buildings in Germany).

The Dislocation of the Modernist Agenda

During the nineteenth century, the artistic current later called Modernism arose from the same reaction against dislocated architecture that had given birth to the Arts and Crafts movement. The academic study of historic styles of architecture had led to the possibility of using any of them, singly or together, for any project anywhere. Especially notable here is Owen Jones, *The Grammar*

of Ornament (Day and Sons, London, 1856). This repetition of historic styles caused unease in those who had ideas about authenticity. There were two conflicting responses. The Arts and Crafts architects chose only relevant local styles to work in, re-casting them for contemporary use. Others, the Modernists, chose to reject all former styles as 'social dishonesty', and sought to create an ahistorical style that they thought would be fitting for what they called the Machine Age.

The most influential of the Modernists, in seeking authentic, true principles, often overlooked the genuine craft techniques involved in making things, and only saw that, in terms of style, this 'pick-and-mix' eclectic architecture should be abolished. This led them to seek ways of dispensing with all historic forms, relying instead upon an 'essentialist' approach, using in general the simple forms of Euclidean geometry, and the aesthetic of the machine.

Born of its time, this geometrical Modernism became inextricably linked with a utopian agenda that attempted to create a 'brave new world' that would supersede and destroy past ways of doing things. This new age would, its protagonists claimed, be freed from what they saw as the burden of the past by means of the unlimited transformation of nature and human beings through science. Following this agenda, modern architecture lost its connection with place and materials, becoming instead a branch of abstract sculpture using various proportional systems. With little understanding of the ecological implications of traditional building, plain geometric shapes were confused with functionality, and the reason for the various complex forms of traditional architecture was ignored.

Local traditional materials could not easily fit in with this new sculptural agenda, for natural materials, human scale, traditional beauty and longevity were decried as principles unsuitable for the new age of speed and action. Instead, the now-universal reinforced concrete, steel, glass and plastic, Quinlan Terry's 'new materials', were substituted for the wood, brick, stone, slate, stucco and tile that had served well for three millennia or more. Buildings made in the new way looked different, and so were a visible statement of change. When it was thought about at all, the longevity or

otherwise of these 'new materials' was considered secondary to the visual effect that they could achieve.

And that is what was wanted. The elitist world of the artist, with its ever-changing but essentially trivial fashions, became the driving force of architecture. According to this ethos, the designer must appear to be unique, pioneering or inimitable. Even the fame of infamy is thought superior to being an unrecognised, if honest, craftsperson. During the twentieth century, this world-view was reinforced by the creation of an ever-expanding modernist architectural mythos, complete with its canon of famous architects and famous buildings, continually celebrated in magazines, books, films and the electronic media. Rarely are these iconic buildings described in practical terms – what it is like to live or work in them, how much they cost to run, and how long they last without major repairs.

A perfect instance of this is Frank Lloyd Wright's masterpiece, *Fallingwater,* at Mill Run, Pennsylvania, U.S.A. (1934–7). Less than sixty years after its completion, the famous cantilevered concrete terraces over the Bear Run waterfall were sagging and crumbling, so, to prevent their collapse, they were shored-up with steel beams. Early in 2000, this structural failure, added to the leaking roof and windows, forced the owner, the Western Pennsylvania Conservancy, to spend seven million dollars to 'restore' the building. Among other things, this reconstruction involved embedding new steel cables in the rotting concrete so that it appears sound.

As Modernism spread from its urban centres of origin, the traditional crafts of building in country regions were progressively downgraded. The cult of originality, self-expression and individuality in art, paradoxically often presented under the guise of revolutionary collectivism, the self-styled *Avant-Garde* seriously undermined the perceived value of practical skills. It is telling that the words *Avant-Garde* were used. *Avant-Garde* is a French military term, used to describe the soldiers at the front of an army who make the first attack upon the enemy. It carries with it connotations of fitness and courage, referring in its proper use to a body of elite fighting men, the best who lead the rest. The

inference is that the rest will follow those who have the audacity to lead.

Under Modernism, standardised factory-made components, and standardised building regulations reduced the opportunity and even the ability of builders to erect buildings according to local traditional principles. Because of this, many of the roots of everyday experience were eradicated from large sections of society, and even from whole countries. Today, only a relatively small number of craftspeople continue the architectural tradition, maintained largely by the need to restore old buildings, rather than the construction of new ones.

This has led to a paradoxical situation. Today, people accept that dilapidated old buildings should be restored in the same manner in which they were built. This is even extended sometimes to the recreation of a replica of one that has been destroyed, such as the stave church at Fantoft, Norway, burnt in 1992. But when an old building has to be demolished, then the new one that replaces it rarely continues the constructional principles and artistic spirit of the old one. The reconstruction of European cities after the devastation of World War II, for instance, was carried out in most instances with scant regard for the spirit of the place. It has left a legacy of disintegrating Modernism that itself has come up for replacement a mere half century later.

Craftsmanship in Para- and Post-Modernism

Historians of architecture often appear uncertain about those early twentieth century architects that were rooted in Arts and Crafts traditions but used them in a modernist way. Intermediate forms are difficult to categorise, and so these works are frequently give the label 'expressionist'. Expressionism, however, is a well-defined school of painting whose works do not closely resemble the architecture given the same name. Among the most notable instances of this modern continuation of the Arts and Crafts into and beyond the first quarter of the twentieth century are the Amsterdamse School in the Netherlands and the Worpswede artists in Germany, of whom Bernhard Hötger was the most inventive. The Amsterdamse School was a diverse movement that

built everything from cottages and kiosks to tram depots, schools, office blocks and street furniture (Casciato 1996). The ruling artistic schemata, which were rooted in spiritual principles, produced remarkable structures that were functional and decorative at the same time, employing the Dutch craft traditions of bricklaying, carpentry, ironworking and glass leading.

Like the smaller buildings of the Amsterdamse School, Hötger's buildings used traditional materials in a new way. The Worpswede Café is a *Fachwerk* structure with brick nogging (*vide* Lane 2000: 270–3). The overall structure of this timber framing is arranged according to traditional principles, but in a form unlike anything else in either traditional or modernist architecture. One might call it radical traditionalist art, where traditional principles are used in a way quite different from the received tradition. The brick nogging follows north German tradition in places, but its overall pattern is again asymmetrical.

The worldwide depression of the 1930s caused the cessation of most traditional and radical traditionalist building in Europe (e.g. the London Building Guilds collapsed in 1930). In countries with totalitarian governments, an architecture of grandiose gestures emerged. It drew upon the outer forms of classicism cladding modernist reinforced concrete structures. After the destruction of World War II (1939–45), cheapness became the guiding principle, and governments followed the agenda of modernist architects which helped to de-skill society.

Hungarian organic architecture emerged in the 1970s as a reaction to totalitarianism and loss of skills. It was a remanifestation of the arts and crafts principles based on the ideas of architect Károly Kós and the composer Béla Bartók. Kós (1883–1977), was the leader of the *Fiatalok* (Young Architects movement), influenced by the Arts and Crafts movement of Britain. The organic architects' intention was to express oneness with nature through the local traditions in building, using timber as the main structural material.

This was expressed in an influential 1973 manifesto, *Only From Pure Sources*, that drew from local traditions of timber building as well as forms from nature (Cook 1996: 18–19). This is the usual English title, perhaps better translated as 'only from clear running

springs', a line from Béla Bartók's *Cantata Profana: The Nine Enchanted Songs* (1930). This is a song cycle based on a Romanian legend that tells of the transformation of nine young men into stags. The buildings that resulted from *Only From Pure Sources* are remarkable instances of radical traditionalism. András Erdei, the architect of the house of the woodcarvers at Velem (1978–80) stated that he saw his work as part of a continuity that honours life (Cook 1996: 102). Some Hungarian organic buildings carry further the art of roofing seen on churches in Romania (e.g. at Sugatag and Birsana) with shingles over roof surfaces that undulate in three dimensions, such as the meeting hall at Ceglépuszta designed by Ervin Nagy (1984–6).

In other countries, the recognition that the environment is threatened by human activities has led architects to look again at traditional materials and constructional principles as more ecologically sound (e.g. Schwabe and Rother 1985). In smaller buildings at least, the automatic choice of concrete in building has been challenged since the 1980s in Britain. Unfortunately, most new buildings made of traditional materials are often poor pastiches of those around them, and, to make things worse, the quality of craftsmanship is often low. In Germany, this is called *Heimatkitsch* ('homeland kitsch'). The new townships of Cambourne in Cambridgeshire and Barlborough Links in north Derbyshire have this kind of building.

However, the local and universal principles that underlie the older buildings are by no means lost, and most of the materials are still available locally. They can easily be recovered and used for new buildings, and the skills, where lacking, can be taught. Some attempt at this is being made in various parts of Britain (e.g. Jennings 1993; Joyce, Michell and Williams 1996: 9–12).

When they are made according to these principles, they are truly reflective of the present, whilst maintaining the traditional principles of the place in which they are built (fig. 30). The ideal 'located architecture' lies in the creation of buildings that express the spirit of the place through material forms, and through a sympathetic understanding of local tradition in its widest sense, the new can be part of this continuity.

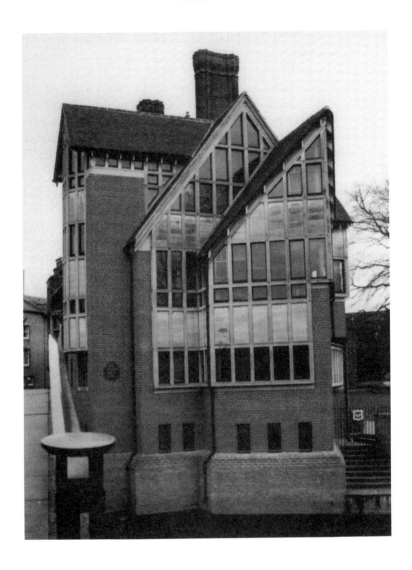

Figure 30. The Arts and Crafts tradition continued; the Jerwood Library, Trinity Hall, Cambridge, built in 1997 with brickwork in English Garden Wall Bond, oak timber-frame superstructure and hand-made tiles.

Glossary

Abbreviations used:

Arcade post: one of a row of posts supporting an arcade plate in an aisled building.

Arcade plate: longitudinal timber serving as a purlin (q.v.) in an aisled building, linking both common rafters and tie beams (q.v.).

Arch-braces: a pair of touching curved braces, often supporting a tie-beam or a collar (q.v.), forming an arch.

Bardeau: wooden shingle (F).

Bâtière: French cruck roof construction (F).

Brace: timber component completing a triangle to create a rigid structure.

Bressummer: intermediate structural timber, supporting the ends of floor joists or a chimney.

Bundwerk: long-post timber frame structures, mainly in Bavaria, characterised by its bands of close latticework framing (G).

Butt purlin: a tenoned purlin, jointed into the principal rafters.

Charpente à bois long: long-post timber framing, where two or more storeys are supported by single posts (F). Called *Ständergeschossbauweise* in German-speaking countries.

Charpente à bois court: short-post framing, where each storey has its own frame (F), *Fachwerkbauweise* in German-speaking countries.

Clay lump: East Anglian mud bricks, used for walls, but more commonly in nogging timber frames (c.f. Polish *pecki*).

Close studding: studs (q.v.) set close together, about a width apart.

Cob: mixture of earth, clay, sand and stones bound with hair or straw (c.f. Dabbin, Wychert).

Collar: horizontal timber connecting a pair of rafters at a point below the apex.

Continen: a west Slavonic temple, from the Polish *konczyna*, an 'end' or 'gable' (OS).

Cornier: a post at the junction of two walls in a timber frame building (F).

Crannóg: artificial timber island in a lake (Ga).

Crown Plate: timber along the length of a roof, supported by a series of crown posts.

Crowntree: cross-timber that carries the weight of the buck of a post mill on top of the main post (*standaard*, q.v.).

Cruck building: named from the characteristic opposed curving timbers (crucks) that make the A-frame that support the roof (cf. *Bâtière*).

Dabbin: Cumbrian cob (q.v.).

Dovetail: reversed wedge-shaped joint, withstanding tension.

Dragon Post: Jowled corner post of a building that supports a projecting diagonal beam, frequently connected with jetties along two sides. The dragon post is an inverted timber.

Épure: area for assembling frames, a geometrical 'tracing floor' or framing ground (F).

Fachwerk: short-post timber frame structure (G).

Firstpfette: ridge-beam (q.v.) (G).

Framing ground: area for constructing timber frames prior to erection.

Fussband: sole-plate (G).

Heck post (or speer-post): post that supports the end of the pannelled screen next to the fireplace in Yorkshire buildings.

Herrgottswinkel: 'Lord God's corner', otherwise *Herrgottseck* or *Heilige Hinterecke* ('holy back corner'), traditionally the form of a wooden shrine, built into the fabric of the house in the corner of the living room (G).

Hof: a Norse temple (ON).

Hoslur: an enhazelled area, set aside from the world by hazel posts (ON).

Jetty: joists projecting beyond the floor below, supporting an overhanging upper frame.

Joist: horizontal timber supporting a floor.

Jowl: enlarged head of a main post, otherwise called the rootstock because the post is inverted from the way it grew.

King Post: vertical roof timber supporting a ridge-beam (q.v.).

Kopfband: longitudinal beam at the top of a wall (G).

Lath and Plaster: timber frame covering of wooden laths nailed to the frame, and covered with plaster. Often the base for pargetting (q.v.).

Makelaar: windmill hip-knob with grooves designed to make a sound in the wind (D).

Mann: assembly of braces around an upright in Alamannic *Fachwerk* forming a symmetrical pattern (G).

Midtmast: centre mast (spire-mast) of Scandinavian church spires (N).

Mondscheiben: 'moon panes', circular panes of crown glass about 10 inches diameter used in central Europe (G).

Mud and Stud: light stave building plastered with mud, known from Lancashire and Lincolnshire.

Murus Gallicus: continental Celtic stone-infilled timber defensive walling (L)

Nogging: infill of timber frame panels with stones, slates, tiles or bricks.

Opus Craticium: timber frames with nogging of stones and concrete in Roman building (L).

Pan de bois: timber frame structure (F).

Pargetting: plaster cladding with stamped or drawn designs.

Pattress Plate: dished circular wall-anchor (q.v.).

Pecki: unfired clay bricks, used in Polish nogging (q.v.) (P).

Plate: a horizontal timber at the top or bottom of a frame.

Purlin: Longitudinal roof timber, usually halfway up the rafters, connecting the common rafters with the principal ones.

Rafter: Timbers that support the roof, running from wall plate (q.v.) to the ridge. Divided into principal rafters, connected with the main framing, and common rafters, which are secondary structures held in place by purlins (q.v.).

Rail: horizontal timber.

Ridge-beam: longitudinal beam running along beneath the roof ridge, supporting the heads of the rafters (cf. German *Firstpfette*).

Shrough Shed: temporary structure used to house animals (EA).

Sill: the base of a wall frame (cf. German *Fussband*).

Sill-beam: beam at the base of a wall.

Sole: a sill that rests in a trench or upon the earth (F).

Sole plate: timber functioning as a sill-beam (q.v.).

Solin: a sill raised upon stones, drystone or masonry walls (F).

Speer-post (or heck post): post that supports the end of the pannelled screen next to the fireplace in Yorkshire buildings.

Spinmolen or spinnertje: 'spider mill' or whirligig whose rotation denotes both wind speed and direction (D).

Spire-mast: centre-support timber of a church spire, running from a basal frame to the apex.

Staddle stone: mushroom-shaped stone pillar supporting a timber-

frame granary or storehouse.

Stafgarðr: a 'fenced enclosure', sacred place in the old religion of the north (ON).

Standaard: the main post that supports a post mill (D).

Stud: vertical timber without primary supporting function.

Sypance: vaulted log ceiling (P), similar to the German *Bohlenbälkchendecke*.

Takfot: beam at the top of the wall supporting the *bindbjalke* (rafters), traditionally carved with interlace, foliate and zoomorphic patterns (N).

Totenbaum: 'tree of the dead', Alamannic coffin hewn from a single trunk of an oak tree, often with a serpent carved on the lid (G).

Tie-beam: transverse beam that links the tops of two walls, resisting the outward thrust of the roof above.

Tjösnur: peg with carved head used to hold down the square hide on which single combat was fought in Icelandic *holmganga* (ON).

Truss: transverse timber frame supporting a roof at bay intervals.

Vébond: fence enclosing a heathen sacred place (ON).

Vouissoir: brick shaped to be part of a fan-shaped window head.

Wall-anchor: end plate of an iron or steel tie bar serving to resist outward stresses on brick walls (cf. Pattress Plate).

Wall-plate: longitudinal beam at the top of a wall (cf. German *Kopfband*).

Wattle and Daub: interwoven hazel staves and horizontal withies filled with clay, dung, animal hair, as infill of timber framing, finished inside and out with a coat of plaster.

Weatherboarding: horizontal boarding pegged or nailed to a timber frame. Early examples (16th century), are in oak or elm, later usually in deal. Weatherboarding is tarred or painted.

Wilden Mann: assembly of symmetrical overlapping braces around an upright in Alamannic *Fachwerk* (G).

Wychert: Buckinghamshire cob walls (q.v.).

Zimmermann: member of the German carpenter-builders' guild.

Bibliography

Anon., 2000, *The Rose Theatre, Past, Present and Future*, Museum of London.

Anon., 2002, 'Highway to Hell', *Kerrang!* 791, 22–4.

Ahrens, Claus, 1982, *Frühe Holzkirchen im Nördlichen Europa*. Th. Dingwort and Sohn, Hamburg.

Ahrens, Klaus, 1997, 'Zur Herkunft der Norwegische Säulenstabkirchen', *Zeitschrift für Archäologie des Mittelalters*, 66.

Anker, Peter, 1975, *Folkekunst I Norge*, J. W. Cappelens Forlag, Oslo.

Anscombe, Isabelle, 1999, *Arts and Crafts Style*. Phaidon Press.

Appulm, Horst (ed.), 1994, *Johann Siebmeyer's Wappenbuch* (1605); Harenberg Edition, Dortmund.

Ashbee, C.R., 1909, *Craftsmanship in Competitive Industry*. Essex House Press, Campden.

Aswynn, Freya, 1988, *Leaves of Yggdrasil*, Aswynn, London.

Ayers, Bryan, 1985, 'Excavations within the north east Bailey of Norwich Castle, 1979', *East Anglian Archaeological Report* 28.

Bächtold-Stäubli, Hanns (ed.), 1927–1942, *Handwörterbuch des Deutschen Aberglaubens*, 9 vols., Koehler and Amerlang, Berlin.

Badger, A.B., 1893, 'An English Venice', *The Midland Naturalist*, 16, 242–3.

Banks, M.M., 1935, 'Tangled thread mazes', *Folk-Lore*, 46, 78–80.

Baring-Gould, S., 1909, *A Book of Devon*, Methuen and Co., London.

Barner, Wilhelm, 1968, *Bauopfer und Hausschutzauber im Land zwischen Hildesheimer Wald und Ith*. Buchdruckerei und Verlag August Lax, Hildesheim.

Barrett, W.H. and R.P. Garrod, 1976, *East Anglian Folklore and Other Tales*, Routledge and Kegan Paul.

Bartram, Alan, 1978 *Fascia Lettering in the British Isles*. Lund Humphries, London.

Bauer, Gottfried and Ulrich Theurer, 2000, *Von der Strassenbahn zur Stadtbahn Stuttgart 1975–2000*, Stuttgarter Strassenbahnen AG, Stuttgart.

Bendermacher, Justinus, 1954, 'Über eine Hausform mit Dächern ohne Querverband', *Zeitschrift für Volkskunde*, 50, 106–23.

Binder, Pearl, 1973, *Magic Symbols of the World*. Hamlyn, London.

Blair, Peter Hunter, 1963, *Roman Britain and Early England 55 B.C. – A.D. 871*, John Donald, Edinburgh.

Bock, Manfred, Sigrid Johanisse and Vladimir Stissi, 1997, *Michel de Klerk, Architect and Artist of the Amsterdam School*, N.A.I. Publishers, Rotterdam.

Borsi, Franco and Ezio Godoli, 1985, *Wiener Bauten der Jahrhundertwende*, Nicol Verlagsgesellschaft, Hamburg.

Brears, Peter, 1981, *Horse Brasses*, Country Life, Feltham.

Brears, Peter, 1989, *North Country Folk Art*. John Donald, Edinburgh.

Brennan, Betty, 1985, letter, *Daily Mirror*, 1 October.

Brett, David, 1992, *On Decoration*. The Lutterworth Press, Cambridge.

Brill, Edith, 1990, *Life and Tradition on the Cotswolds*. Alan Sutton, Gloucester.

Brunskill, R.W., 1987, *Illustrated Handbook of Vernacular Architecture*. Faber and Faber, London.

Bugge, Gunnar, 1983, *Stave Churches in Norway*. Dreyers Forlag, Oslo.

Bugge, Gunnar, and Bernardino Mezzanotte, 1994, *Stabkirchen – Mittelalterliche Baukunst in Norwegen*. Regensburg.

Bunker, B., no date, *Cruck Buildings*, privately published, Holmesfield.

Bunn, Ivan, 1982, ' "A Devil's Shield..." Notes on Suffolk Witch Bottles', *Lantern* 39, 3–7.

Buschan, Georg, 1926, *Illustrierte Völkerkunde*, Strecker and Schröder, Stuttgart.

Canney, Maurice A., 1926, 'The use of sand in magic and religion', *Man*, January, 13.

Casciato, Maristella, 1996, *The Amsterdam School*, 010 Publishers, Rotterdam.

Cass, Eddie and Steve Roud, 2002, *An Introduction to the English Mummers' Play*, English Folk Dance and Song Society in association with the Folklore Society, London.

Caton, Judi, 1988, *Oxford in Old Photographs*. Alan Sutton, Gloucester.

Chaney, William A., 1970, *The Cult of Kingship in Anglo-Saxon England*, Manchester University Press.

Chevalier, Jacques and Georges Raffignon, 1941, *La Forêt de Tronçais*, Limoges.

Christie, Håkon, 1991, 'Kirkebygging I Norge I, 1600– og 1700– Årene', *Forenigen Til Norske Fortidsminnes-Merkers Bevaring Årbok* 145, 177–94.

Cobb, Gerald, 1948, *The Old Churches of London*. Batsford, London.

Collingwood, W.G., 1927, *Northumbrian Crosses of the Pre-Norman Age*, London.

Collingwood, W.G. and Jón Stefánsson (trans.), 1902, *The Life and Death of Cormac the Skald*, William Holmes, Ulverston.

Comino, Mary, 1982, *Gimson and the Barnsleys*, Van Nostrand Reinhold, New York.

Cook, Jeffrey, 1996, *Seeking Structure from Nature*, Birkhäuser Verlag für Architektur, Basel.

Cooper, Emmanuel, 1994, *People's Art: Working-class Art from 1750 to the Present Day*. Mainstream Publishing, Edinburgh/London.

Corcoran, Michael, 2000, *Through Streets Broad and Narrow. A History of Dublin Trams*. Midland Publishing, Earl Shilton.

Croker, Alec, 1971, *The Crafts of Straw Decoration*, Dryad, Leicester.

Dacombe, Marianne, 1935, *Dorset Up Along and Down Along*, Bridport.

Dakers, Alan, 1991, *Ticklerton Tales. A history of Eaton-under-Heywood*, privately published, Church Stretton.

D'Argenville, Antoine-Joseph Dezallier, 1709, *La Théorie et Pratique du Jardinage*, Paris, 1709; Hildesheim/New York 1970.

Davídhsson, Ólafur, 1903, 'Isländischer Zauberbücher und Zauberzeichen', *Zeitschrift des Vereines für Volkskunde,* 13, 150–167.

Davidson, Hilda Ellis, 1993, *The Lost Beliefs of Northern Europe,* Routledge, London.

Day, George, 1894, 'Notes on Essex dialect and folk-lore...', *The Essex Naturalist,* 8, 77.

de Bruyn, A.G., 1929, *Geesten en Gouden in Oud Oldenzaal.* Oldenzaal.

de Givry, Grillot, 1973, *Illustrated Anthology of Sorcery, Magic and Alchemy.* Causeway Books, New York.

Denyer, Susan, 1991, *Traditional Buildings and Life in the Lake District.* Victor Gollancz Ltd./ Peter Crawley, London.

de Vinsauf, Geoffrey, 1924, 'Poetria Nova', in E. Faral, *Les Arts Poétiques du XII^e et du XIII^e Siècle,* Paris.

Devliegher, Luc, 1980, 'De Noordmolen te Hondschote', *De Franse Nederlanden Jaarboek 1980,* 191–203.

Deyda, Brigitte, et. al., 1995, *Technologie für Holzberufe.* Verlag Dr Max Gehlen, Bad Homburg.

Dietrichson, Lorenz, 1892, *De Norske Stavkirker, studier over deres System, oprindelse og Historiske Udvikling,* Alb. Cammermeyers Forlag, Christiania/Copenhagen.

Dietrichson, Lorenz and Holm Munthe, 1893, *Holzbaukunst Norwegens in Vergangenheit und Gegenwart,* Dresden.

Ditchfield, P.H., 1985, *The Manor Houses of England.* Bracken, London.

Dixon, G.M., 1981, *A Heritage of Anglian Crafts,* Minimax Books, Deeping St. James.

Dodds, George, 1870, 'The translation of an ancient formula of magical exorcism, written in cipher', *The Reliquary,* January, 129–38.

Dunduliene, Prane, 1991, *Lietuvos Etnologija.* Mokslas, Vilnius.

Ebbage, Sheridan, 1976, *Barns and Granaries.* The Boydell Press, Ipswich.

Eliëns, Titus M., Marjan Groot and Frans Leidelmeijer (eds), 1997, *Avant-Garde Design. Dutch Decorative Arts 1880–1940.* Philip Wilson Publishers, London.

Essink, H.B.M., 1953, 'Een Bouwoffer te Baardwijk', *Brabants Heem*, 5, 109–10.

Evans, E. Estyn, 1957, *Irish Folk Ways*, Routledge and Kegan Paul, London.

Evans, George Ewart, 1966, *The Pattern under the Plough*, Faber, London.

Faucon, Régis and Yves Lescroart, 1997, *Manor Houses in Normandy*, Könemann, Cologne.

Fehring, Günter P., 1996, 'Stadtarchäologie in Lübeck 1973–1993', *Zeitschrift für Archäologie des Mittelalters*, 145–60.

Ferne, John, 1586, *The Blazon of Gentrie*, London.

Field, Robert, 1996, *Geometric Patterns from Tiles and Brickwork*, Tarquin Publications, Stradbroke.

Filipetti, Hervé, and Janine Troterau, 1978, *Symboles et Pratiques Rituelles dans la Maison Traditionelle*. Éditions Berger Lerrault, Paris.

Fiodorov, Boris, 1976, *Architecture of the Russian North, 12th–19th Centuries*, Aurora Art Publishers, Leningrad.

Flowers, Stephen, 1989, *The Galdrabók. An Icelandic Grimoire*. Samuel Weiser, York Beach.

Flüeler, Marianne and Niklaus Flüeler (eds), 1992, *Stadtluft, Hirsebrei und Bettelmönch*, Landesdenkmalamt Baden-Württemberg und der Stadt Zürich, Stuttgart.

Forby, Robert, 1830, *The Vocabulary of East Anglia*, 2 vols., J.B. Nichols and Son, London,.

Forty, Adrian, 1986, *Objects of Desire: Design and Society since 1750*. Cameron Books, Moffat.

Foster, H. (ed), 1985, *Post Modern Culture*. Pluto Press, London.

Frazer, James George, 1922, *The Golden Bough*, abridged 3rd edition, London.

Frys, Ewa; Anna Iracka and Marian Pokropek, 1988, *Folk Art in Poland*. trans. Jerzy A. Baldyga, Warsaw.

Fryske Akademy Commission, 1956, 'De Fryske Flagge' *It Beaken* Jiergong 18, 2/3, 62–86.

Gaitzsch, Wolfgang, 1986, *Antike Korb- und Seilerwaren*. Gesellschaft für Vor- und Frühgeschichte in Württemberg und Hohenzollern, Aalen.

Gettings, Fred, 1981, *Dictionary of Occult, Hermetic and Alchemical Sigils*. Routledge and Kegan Paul, London.

Gielzynski, Wojciech, Irena and Jerzy Kostrowicki, 1994, *Poland*, Arkady, Warsaw.

Gifford, W. (ed.), 1816, *The Works of Ben Jonson, in Nine Volumes, with Notes Critical and Explanatory, and a Biographical Memoir*. Nicol, Rivington, Cadell & Davis et. al., London.

Glassie, Henry, 1989, *The Spirit of Folk Art*. Museum of International Folk Art, Santa Fe.

Godoli, Ezio and Franco Borsi, 1985, *Wiener Bauten der Jahrhundertwende*. Nikoll Verlagsgesellschaft, Hamburg.

Goethe, Friedrich, 1971, 'Der Schwan auf Kirchen Ostfrieslands und Oldenburgs', *Ostfriesland* 4, 7–19.

Goll, Jürg, 1992, 'Baumaterial', in Flüeler and Flüeler, *Stadtluft, Hirsebrei und Bettelmönch*, Stuttgart, 175–257.

Gombrich, E.H., 1963, *Meditations on a Hobby Horse and other Essays on the Theory of Art*. Phaidon Press, London.

Gradidge, Roderick, 1981, *Edwin Lutyens Architect Laureate*, George Allen and Unwin, London.

Greenfield, Jon, 1997, 'Timber Framing, The Two Bays and After', in Mulryne and Shewring, *Shakespeare's Globe Rebuilt*, Cambridge University Press, London, 97–120.

Grose, F. (ed.), 1775 *The Antiquarian Repertory*, 4 vols., London.

Groves, Derham, 1991, *Feng-Shui and Western Building Ceremonies*. Graham Brash, Singapore.

Guibal, Jean, 1982, *L'architecture Rurale Français, Bourbonnais et Nivernais*, Musée Nationale des Arts et Traditions Populaires, Paris.

Haigh, Diane, 1995, *Baillie Scott. The Artistic House*, Academy Editions, London.

Halbout, Patrick and Jacques le Maho (eds.), 1984, *Aspects de la Construction de Bois en Normandie*, Cahiers des Annales de Normandie, 16, Caen.

Hall, Hubert and Frieda J. Nicholas, 1929, 'Select tracts and table books relating to English weights and measures (1100–1742)', *Camden Miscellany*, 15, vii–xviii, 1–68.

Hammarstedt, N.E.: *Svensk Forntro och Folksed*. Nordiska Museet, Stockholm, 1920.

Hancox, Joy, 1992, *The Byrom Collection*, Jonathan Cape, London.

Harris, Richard, 1984, *Discovering Timber-Framed Buildings*, Shire Publications, Princes Risborough.

Hartley, Marie and Joan Ingilby, 2001, *The Old Hand-Knitters of the Dales*. Smith Settle, Otley.

Harvey, John, 1958, 'Medieval Design', *Transactions of the Ancient Monuments Society*, N.S. 6, 55–72.

Haseloff, Günther, 1979, *Kunststile des Frühen Mittelalters*. Württembergisches Landesmuseum, Stuttgart.

Haupt, Albrecht, 1909, *Die Baukunst der Germanen von der Völkerwanderung bis zu Karl dem Grossen*. H.A. Ludwig Degener, Leipzig.

Hayes, R.H. and J.G. Rutter, 1972, *Cruck-Framed Buildings in Ryedale and Eskdale*. Scarborough Archaeological and Historical Society, Scarborough.

Hayward, L.H., 1938, 'Shropshire Folklore of Yesterday and Today', *Folk-Lore*, 49, 236.

Helm, Heide (ed.), 1995, 'Im Zeichen des Kreuzes. Tattoos als Identifikationszeichen', *Körperkult. Tätowier Magazin Ethno-Sonderband*, 15 –21.

Herbert, Kathleen, 1994, *Looking for the Lost Gods of England*, Anglo-Saxon Books, Hockwold cum Wilton.

Herbord, 1894, *Herbords leben des Bischofs Otto von Bamberg*, Leipzig.

Herity, Michael, 1993, 'The tomb-shrine of the founder saint', in Michael R. Spearman and John Higgitt (eds.), *The Age of Migrating Ideas*, Alan Sutton Publishing, Edinburgh, 191–4.

Hersey, J., 1988, *The Lost Meaning of Classical Architecture*. M.I.T. Press, Cambridge, Mass..

Herrmann, H.A., 1942, ' "Mühle" und "Donnerbesen" ', *Germanien*, 333.

Hewett, Cecil Alec, 1969, *The Development of Carpentry 1200–1700*, David and Charles, Newton Abbot.

Hewett, Cecil Alec, 1976, 'Aisled timber halls and related

buildings, chiefly in Essex', *Transactions of the Ancient Monuments Society*, N.S. 21 (1975–76), 45–99.

Hinz, Johannes, 1996, *Pommern*, Bechtermünz Verlag, Augsburg.

Hojer, Gerhard (ed.), 1986, *König Ludwig II-Museum Herrenchiemsee*. Hirmer, Munich.

Holmes, Reg and Pamela Blakeman, 1983, *Ely Tokens*, privately published, Ely.

Home, Gordon, 1927, *Mediaeval London*, Ernest Benn, London.

Horn, Walter, 1958, 'On the Origins of the Mediaeval Bay System', *Journal of the Society of Architectural Historians*, 23, 2–23.

Hundertwasser, Friedensreich, 1991, 'The life of paint materials', in Harry Rand, *Hundertwasser*, Taschen, Cologne, 89, 92–3, 98.

Huys, Paul, 1993, 'Molens in Veelvoudig Perspektief', *Kultureel Jaarboek Oost-Vlaanderen*, Bijdragen Nieuwe Reeks, 36, Ghent.

Innocent, C.F., 1916, *The Development of English Building Construction*. Cambridge University Press, Cambridge, 1916.

Ionescu, Grigore, 1982, *Architectura pe teritoriul României de-a Lungul Veacurilor*. Editura Academiei, Bucharest.

Ivanits, Linda J., 1989, *Russian Folk Belief*, M.E. Sharpe, Armonk.

Jenkins, J. Geraint, 1972, *The English Farm Wagon*. David and Charles, Newton Abbot.

Jennings, Celia (ed.), 1993, *Patterns for Suffolk Buildings: A simple design guide*. Suffolk Building Preservation Trust, Lavenham.

Johnson, Walter, 1912, *Byways in Archaeology*, Cambridge University Press.

Jones, David, 1959, *Epoch and Artist*. Faber and Faber, London.

Jones, Owen, 1856, *The Grammar of Ornament*. Day and Sons, London.

Jones, Prudence and Nigel Pennick, 1995,:*A History of Pagan Europe*. Routledge, London.

Jonson, Ben, 1816, 'The Masque of Blackness', in Gifford, W. (ed.), *The Works of Ben Jonson*, 9 vols., Vol. 7, G. and

W. Nicol, *et. al.*, London.

Joyce, Barry; Gordon Michell and Mike Williams, 1996, *Derbyshire Detail and Character*, Alan Sutton, Stroud.

Kalter , Johannes (ed.), 1991, *The Arts and Crafts of the Swat Valley: Living traditions in the Hindu Kush*, Thames and Hudson, London.

Kaplan, Wendy (ed.), 1996, *Charles Rennie Mackintosh*. Glasgow Museums and Abbeville Press, New York.

Keverne, Richard, 1955, *Tales of Old Inns*. Collins, London.

Kiesewetter, Carl, 1893, *Faust in der Geschichte und Tradition*. Leipzig.

Knapas, Marja Terttu, 1990, 'Öm klockornas placering I finländska medeltidskyrkor', *Hikuin*, 17, 255–70.

Koch, Rudolf, 1930, *The Book of Signs*, The First Edition Club, London.

Kodolányi, J. Jr., 1968, 'Khanty (Ostyak) sheds for sacrificial objects', in V. Diószegi, (ed.), *Popular Beliefs in Siberia*, Indiana University Press, Bloomington.

Kornwolf, James D., 1972, *Baillie Scott and the Arts and Crafts Movement*. Johns Hopkins Press, Baltimore and London.

Kossmann, Bernhard and Max Hummel, 1906, *Das Bauernhaus im Deutschen Reiche: Baden*. Berlin, reprinted Verlag Th. Schäfer, Hanover, 1990.

Krauth, Theodor, and Franz Meyer, 1895, *Das Zimmermansbuch*. Leipzig, reprinted Freies Geisterleben, Stuttgart, 1979.

Kruft, Hanno-Walter, 1985, *Geschichte der Architekturtheorie: Von der Antike bis zur Gegenwart*. Verlag C.H. Beck, Munich.

L'Agneau, 1636, *Harmonie Mystique, ou accord des philosophes chymiques*, Paris.

Lake, Jeremy, 1989, *Historic Farm Buildings*, Blandford, London.

Lambert, Margaret and Enid Marx, 1989, *English Popular Art*, Merlin Press, London.

Lane, Barbara Miller, 2000, *National Romanticism and Modern Architecture in Germany and Scandinavia*, Cambridge University Press.

Lang, James, 1994, 'The Govan hogbacks: a reappraisal', in Anna Ritchie (ed.), *Govan and its Early Medieval Sculpture*, Alan Sutton Publishing, Stroud, 123–31.

Lang, J.B., 1969, 'Charming of cattle', *Proceedings of the Dorset Natural History and Archaeology Society*, 91, 222–3.

Larmour, Paul, 1992, *The Arts and Crafts Movement in Ireland*. Friar's Bush Press, Belfast.

Larwood, Jacob, and John Camden Hotton, 1985, *English Inn Signs*. Arco, New York.

Leather, Ella Mary, 1912, *The Folk-lore of Herefordshire*, Jakeman and Carver, Hereford; Sidgwick and Jackson, London.

Leather, Ella Mary, 1914, 'Foundation Sacrifice', *Folk-Lore*, 24, 110.

Leech, Michael, 1997, 'Going, going, gone?', *History Today*, October, 36–7.

Leeson, R.A., 1971, *United We Stand: An illustrated account of trade union emblems*, Adams and Dart, London.

Lethaby, W.R., 1892, *Architecture, Mysticism and Myth* (1892), reprinted The Architectural Press Ltd., London, 1974.

Lethaby, W.R., 1956, *Architecture, Nature and Magic*, Gerald Duckworth, London.

Lewery, A.J., 1991, *Popular Art Past and Present*, David and Charles, Newton Abbot.

Lidén, H., 1969, 'From pagan sanctuary to Christian church: the excavation of Maere Church, Trondelag', *Norwegian Archaeological Review*, 2, 23–32.

MacCarthy, Fiona, 1981, *The Simple Life: C.R. Ashbee in the Cotswolds*. Lund Humphries, London.

MacKail, J.W., 1899, *The Life of William Morris*. 2 vols., Longmans, Green and Co., London.

McNeill, F. Marian, 1957–1968, *The Silver Bough*, 4 vols., William MacLellan, Glasgow.

Mair, Craig, 1988, *Mercat Cross and Tolbooth*, John Donald, Edinburgh.

Mann, Ethel, 1934, *Old Bungay*, Methuen, London.

March, H. Colley, 1899, 'Dorset folklore collected in 1897', *Folk-lore*, 10, 483.

Marta, Roberto, 1990, *Architettura Romana, Techniche construttive e forme architettoniche del mondo romano*, Edizioni Kappa, Rome.

Martin, Eugène, 1903–4 'Le coq du clocher', *Memoires de l'Academie de Stanislas*, 6:1, 6.

Martin, Stephen A., 2001, *Archibald Knox*. Artmedia Press, London.

Mockridge, Patricia, and Philip Mockridge, 1990, *Weathervanes of Great Britain*. Hale, London.

Monson-Fitzjohn, G.J., 1926, *Quaint Signs of Olde Inns*. Herbert Jenkins, London.

Moora, H. and A. Viires, 1964, *Abriss der estnischen Volkskunde*, Estonian State Publishers, Tallinn.

Morris, May (ed.), 1910–15, *The Collected Works of William Morris*. 24 vols., Longmans, Green and Co., London.

Morris, William, 1882, *Hopes and Fears for Art*. Ellis and White, London.

Mössinger, Friedrich, 1938a, 'Maibaum, Dorflinde, Weinachtsbaum', *Germanien*, May 145–55.

Mössinger, Friedrich, 1938b, 'Die Dorflinde als Weltbaum', *Germanien*, December, 388–96.

Müller, Joachim, 2000, 'Der Mittelalterliche Holzbau in der Stadt Brandenburg...', *Zeitschrift Für Archäologie des Mittelalters*, 148–58.

Mulryne, J.R. and Margaret Shewring (eds.), 1997, *Shakespeare's Globe Rebuilt*, Cambridge University Press.

Nash, Judy, 1991, *Thatchers and Thatching*. Batsford, London.

Needleman, Carla, 1993, *The Work of Craft*. Kodansha, New York.

Nicolaysen, N., 1882, *The Viking Ship from Gokstad*, Alb. Cammermeyer, Christiania.

Nioradze, Georg, 1925, *Der Schamanismus bei den sibirischen Völkern*, Strecker and Schröder, Stuttgart.

Nodermann, Maj, 1988, 'Hem in Redning', in Nils-Arvid Bringéus et. al. (eds.), *Arbete och Redskap*, Stockholm.

Notebaart, Jannis C., 1972, *Windmühlen*. Mouton Verlag, Den Haag.

Novati, Francesco, 1904–5, '"Li Dis du Koc" di Jean de Condé', *Studi Medievali*, 1, 497.

Nylén, Erik and Jan Peter Lamm, 1981, *Bildsteine auf Gotland*. Karl Wachholz Verlag, Neumünster.

Olbrich, Joseph Maria, 1904, *Ideen von Olbrich*, reprinted Arnold'sche Verlaganstalt, Stuttgart, 1992.

Olsen, O., 1966, 'Hørg, hof og kirke', *Aarbøger for Nordisk Oldkyndighed of Historie 1965*, Copenhagen.

Orme, Nicholas, 1986, *Exeter Cathedral as it was 1050–1550*, Devon Books, Exeter.

Öunapuu, Piret, 2001, 'Aleksei Peterson ja taluarchitektuur', *Muuseum* 2 (11), 14–15.

Owen, Trefor M., 1987, *Welsh Folk Customs*. Gomer, Llandysul.

Owen, Trefor M., 1991, *The Customs and Traditions of Wales*, University of Wales Press, Cardiff.

Owles, Elizabeth and Norman Smedley, 1968, 'Archeology in Suffolk 1967', *Proceedings of the Suffolk Institute of Archaeology*, 31, 80–1.

Pakenham, Thomas, 2001, *Meetings with Remarkable Trees*, Cassell, London.

Pakomka, A., 1991, *Siluzti Staroga Minska*, Minsk.

Palmer, Roy, 1992, *The Folklore of Hereford and Worcester*, Logaston Press, Logaston.

Pantelic, Nikola, 1984,*Traditional Arts and Crafts in Yugoslavia*, Jugoslovenska Revija, Belgrade.

Pareli, Leif, 1984, 'Sørsamenes Byggeskikk', *Forenigen Til Norske Fortidsminnes-Merkers Bevaring Årbok*, 111–24.

Papanek, Victor, 1995, *The Green Imperative. Natural design for the real world*. Thames and Hudson, New York.

Paulsen, Peter, and Helga Schach-Dörges,1972, *Holzhandwerk der Alamannen*. Kohlhammer, Stuttgart.

Parker, C.A. (revised by W.G. Collingwood), 1926a, 'Aspatria. The hogback', *Cumberland and Westmoreland Antiquarian and Archaeological Society*, Extra Series, 15, 15–17.

Parker, C.A. (revised by W.G. Collingwood), 1926b, 'Gosforth. The hogbacks', *Cumberland and Westmoreland Antiquarian and Archaeological Society*, Extra Series, 15, 172–77.

Parker, Vanessa, 1971, *The Making of King's Lynn*. Phillimore, London.

Parry, Linda (ed.), 1997, *William Morris*. Abrams, New York.

Paulsen, Peter and Helga Schach-Dörges, 1972,: *Holzhandwerk der Alamannen*, Verlag W. Kohlhammer, Stuttgart.

Peesch, Reinhard, 1983, *The Ornament in European Folk Art*, Alpine Fine Arts Collection, New York.

Pennick, Ann, 1978, 'Step Charms', *Albion*, 1, 14–15.

Pennick, Nigel, 1980, *Sacred Geometry*, reprinted, Capall Bann, Chieveley, 1994.

Pennick, Nigel, 1985, *The Cosmic Axis*, Runestaff, Bar Hill.

Pennick, Nigel, 1986, *Skulls, Cats and Witch Bottles*, Nigel Pennick Editions, Bar Hill.

Pennick, Nigel, 1990, *Runic Astrology*, Aquarian Press, Wellingborough.

Pennick, Nigel, 1992a, *Magical Alphabets*, Samuel Weiser, York Beach.

Pennick, Nigel, 1992b, 'Parametric Diagrams', in Joy Hancox, *The Byrom Collection*, appendix 1, 291–2, Jonathan Cape, London.

Pennick, Nigel, 1993, *Anima Loci*, Nideck, Bar Hill.

Pennick, Nigel, 1996, *Celtic Sacred Landscapes*, Thames and Hudson, London.

Pennick, Nigel, 1997, *The Celtic Cross. An illustrated history and celebration*, Blandford, London.

Pennick, Nigel, 1998, *Crossing the Borderlines: Guising, masking and ritual animal disguises in the European tradition*, Capall Bann Publishing, Chieveley.

Pennick, Nigel, 1999, *Beginnings: Geomancy, builders' rites and electional astrology in the European tradition*, Capall Bann Publishing, Chieveley.

Pennick, Nigel, 2001, *On the Spiritual Arts and Crafts*, The Library of the European Tradition, Cambridge.

Peterszák, Tivadar, 1989, 'Az Erdomunkások építményei Észak-Magyarországon', *Népi Építészet a Kárpát-Medence Északkeleti Térségében*, Miscolc, 325–36.

Petterson, Lars, 1971, 'Hailuodon Palnut Puukirkko Ja Sen Maalaukset'. *Finnska fornminnesförenigens tidskrift*, 73.

Petterson, Lars, 1978, 'Finnish Cruciform Timber-Churches with 24 Corners'. *Finnska fornminnesförenigens tidskrift*, 79.

Petrie, Flinders, 1930, *Decorative Patterns of the Ancient World*, reprinted Studio Editions, London, 1990.

Pokropek, Marian, 1988, 'Interior', in Iracka and Pokropek Frys, *Folk Art in Poland*, Arkady, Warsaw, 46–75.

Porter, Enid, 1969, *Cambridgeshire Customs and Folklore*. Routledge and Kegan Paul, London.

Pritchard, V., 1967, *English Medieval Graffiti*, Cambridge University Press.

Proctor, J.M., 1981, *East Anglian Cottages*. Providence Press, Ely.

Quiney, Anthony, 1990, *The Traditional Buildings of England*, Thames and Hudson, London.

Propping, Walter, 1935, 'Das "Dag" Zeichen am niedersächsischen Bauernhaus', *Germanien*, 143–6.

Raglan, Lady, 1939, 'The "green man" in church architecture', *Folk-Lore*, 50, 45–57.

Rahtz, P.A., 1979, *The Saxon and Medieval Palaces at Cheddar*, Oxford University Press.

Ray, P.W., 1869, *The History of Greensted Church*, Ongar.

Redknap, Mark, 1991, *The Christian Celts*, National Museum of Wales, Cardiff.

Rees, Alwyn and Brinley Rees, 1961, *Celtic Heritage. Ancient tradition in Ireland and Wales*, Thames and Hudson, London.

Rentschler, Hans, 1926, 'Die schwäbische Bienenzucht einst und jetzt', *Schwäbisches Heimatbuch*, 40–6.

Richmond, I.A., 1932, 'Irish analogies for the Romano-British barn dwelling', *Journal of Roman Studies*, 12, 96–106.

Ritchie, James, 1942, 'The lake-dwelling or crannog in Eadarloch, Loch Treig: its Traditions and its construction', *Proceedings of the Society of Antiquaries of Scotland*, 7th Series, 4, 8–75.

Rohrberg, Erwin, 1981, *Schöne Fachwerkhäuser in Baden-Württemberg*, DRW-Verlag, Stuttgart.

Roller, Hans-Ulrich, 1974, *Volkskultur in Württemberg*. Württembergisches Landesmuseum Stuttgart,

Rønningen, Gunnar, 1991, 'Kirketårn og Takryttere I Norge Fre Middelalderen til 1700–Tallet', *Forenigen Til Norske Fortidsminnes-Merkers Bevaring Årbok 145*, 195–219.

Rubens, Godfrey, 1986, *William Richard Lethaby: His life and work 1857–1931*, Architectural Press, London.

Rushen, Joyce, 1984, 'Folklore and witchcraft in Tudor and Stuart England', *Popular Archaeology*, April, 35.

Russell, Gordon, 1968, *Designer's Trade*. George Allen and Unwin, London.

Sandford, Lettice, 1979, 'Corn Dollies', *The Women's Institute Book of Country Crafts*, The Women's Institute, London, 9–67.

Sandford, Lettice, 1983, *Straw Work and Corn Dollies*, Batsford, London.

Sartori, Paul, 1898, 'Ueber das Bauopfer', *Zeitschrift für Ethnologie*, 30, 1–54.

Schmidt, R.W., 1931, 'Die Stadt Markgröningen und ihr Rathaus', *Schwäbisches Heimatbuch 1931*, 45–54.

Schneider, Jürg E., 1992, 'Fachwerkbau', in Marianne and Niklaus Flüeler (eds.), *Stadtluft, Hirsebrei und Bettelmönch*, Landesdenkmalamt Baden-Württemberg und der Stadt Zürich, Stuttgart, 248–67.

Schnippel, E., 1926, 'Die Englischen Kalenderstäbe', *Leipziger Beiträge zur Englischen Philologie*, 24–105.

Schnitzer, Ulrich (ed.), 1989, *Schwarzwaldhäuser von gestern für die Landwirtschaft von morgen*. Konrad Thiess Verlag, Stuttgart.

Schwabe, K.-H. and G. Rother, 1985, *Angewandte Baubiologie*, Felicitas-Hübner Verlag, Waldeck.

Schuldt, E., 1976, *Der altslawische Tempel von Gross-Radern*. Schwerin.

Scott, Mackay Hugh Baillie, 1906, *Houses and Gardens*. George Newnes, London.

Seymour, John, 1984, *The Forgotten Arts*, Doring Kindersley, London.

Sheehy, Jeanne, 1980, *The Rediscovery of Ireland's Past. The Celtic Revival, 1830–1930*, Thames and Hudson, London.

Shepherd, C.W., 1971, *A Thousand Years of London Bridge*, John Baker, London.

Simpson, Duncan, 1979, *C.F.A. Voysey. An Architect of Individuality*. Lund Humphries, London.

Simpson, W. Douglas, 1933, 'Edzell Castle. Sculptures in the pleasaunce', *Transactions Edinburgh Architectural Association*, 17–24.

Sjömar, Peter, 1995, 'Romansk och gotisk – takkonstruktioner i svenska medeltidskyrkor', *Hikuin*, 22, 207–30.

Skinner, F.G., 1967, *Weights and Measures: Their ancient origins and their development in Great Britain up to AD 1855*. Her Majesty's Stationery Office, London.

Smith, John Thomas, 1861, *The Streets of London*, Richard Bentley, London.

Sowers, Robert, 1990, *Rethinking the Forms of Visual Expression*. University of California Press, Berkeley.

Starmore, Alice and Anne Matheson, 1983, *Knitting from the British Islands*, Book Club Associates, London.

Stevenson, David, 1984, 'Masonry, symbolism and ethics in the life of Sir Robert Moray, F.R.S', *Proceedings of the Society of Antiquaries of Scotland* 114, 405–31.

Stigum, Hilmar, 1945, 'Laftet som Grunnlag for Datiering av Tømmerhus', *By og Bygd Årbok*, 3, 71–88.

Stone, Alby, 1999, 'Hogbacks: Christian and pagan imagery on Viking Age monuments', *3rd Stone*, 33, 16–20.

Stretton, Clement E., 1909, 'The L.and N.W. Railway Company's Diamond or Trade Mark', *Melton Mowbray Times*, 19 February, reprinted in *Journal of Geomancy* Vol. 4/2 (1980), 14.

Strygell, Anna-Lisa, 1974, 'Kyrkans Teken och Årets Gång', *Finnska fornminnesförenigens tidskrift* 77, 46.

Tabor, Raymond, 1994, *Traditional Woodland Crafts*, Batsford, London.

Tebbutt, C.F., 1984, *Huntingdonshire Folklore*, Friends of the Norris Museum, St Ives.

Terry, Quinlan, 1993, 'Seven misunderstandings about Classical architecture', in *Quinlan Terry. Selected Works, Architectural Monographs No. 27*, Academy Editions, London, 129–30.

Thomas, Graham, 1975, 'Cast iron and enamel signs and notices', in P.B. Whitehouse (ed.), *Railway Relics and Regalia*, Country Life, London, 54–65.

Tinniswood, Adrian, 2001, *His Invention So Fertile, a Life of Sir Christopher Wren*, Jonathan Cape, London.

Thorsson, Edred, 1984, *Futhark. A Handbook of Rune Magic*, Samuel Weiser Inc, York Beach (Maine).

Trinkunas, Jonas, 1999, *Of Gods and Holidays*, Tverme, Vilnius.

Turner, Susan, 1975, *The Padarn and Penrhyn Railways*, David and Charles, Newton Abbot.

Turville-Petre, E.O.G., 1964, *Myth and Religion*, New York.

Untermann, Matthias and Jürg E. Schneider, 1992, 'Der steinerne Wohnbau in Südwestdeutschland', in Marianne and Niklaus Flüeler (eds.), *Stadtluft, Hirsebrei und Bettelmönch*, Landesdenkmalamt Baden-Württemberg und der Stadt Zürich, Stuttgart, 225–48.

Valebrokk, Eva and Thomas Thiis-Evensen, 1994, *Norway's Stave Churches, Archaeology, History and Legends*, trans. Ann Clay Zwick, Dreyers Forlag, Oslo.

Vána, Zdenek, 1992, *Mythologie und Götterwelt der slawischen Völker*, Urachhaus, Stuttgart.

van der Klift-Tellingen: Henriette, 1987, *Knitting from the Netherlands. Traditional Dutch fishermen's sweaters*, Dryad Press, London.

Villiers, Elizabeth, 1923, *The Mascot Book*, T. Werner Laurie Ltd, London.

Vitruvius (Marcus Vitruvius Pollo), 1914, *The Ten Books on Architecture*, trans. Morris Hicky Morgan, Harvard University Press, Cambridge, Mass.

von Volborth, Carl-Alexander, 1981, *Heraldry. Customs, rules and styles*, Blandford, London.

von Zaborsky, Oskar, 1936, *Urväter-Erbe in deutscher Volkskunst*. Koehler and Amerlang, Leipzig.

Vriem, Halvar, 1942, 'Takspon og spontekning', *Aarsberetning for Foreningen Norsk Fortids Mindermærkers Bevaring*, 98, Aargang, 27–44.

Walshe, Paul, and John Miller, 1992, *French Farmhouses and Cottages*, Wiedenfeld and Nicolson, London.

Wäre, Ritva, 1991, 'Rakennettu Suomalaisuus', *Finnska Fornminnesförenigens Tidskrift*, 95.

Warren, S. Hazzledine, 1909, 'Charcoal burners in Epping Forest. Their primitive hut and the formation of hut circles', *The Essex Naturalist*, 16, 65–72.

Weiser-Aal, Lily, 1947, 'Magiske Tegn på Norske Trekar?', *By og Byd Årbok*, 117–44.

Werner, Paul, 1988, *Bundwerk in Bayern*, Pannonia Verlag, Freilassing.

West, Trudy and Paul Dong, no date, *The Timber-frame House in England*, David and Charles, Newton Abbot.

Whittick, Arnold, 1971, *Symbols. Signs and their meaning in art and design*. Leonard Hill Books, London.

Whittock, Nathaniel, 1827, *The Decorative Painter and Glaziers' Guide*. G. Virtue, London.

Willett, Fred, 1980, 'Pargetting', in *Bygones*, 5, 6–33.

Williams, H. Fulford, 1951, 'Maze Patterns', *Transactions of the Devonshire Association*, 77.

Wirth, Herman, 1934, *Die Heilige Urschrift der Menschheit*. 9 vols, Koehler and Amerlang, Leipzig.

Wood, Margaret, 1985, *The English Mediaeval House*. Bracken, London.

Woodforde, John, 1985, *Farm Buildings*. Routledge and Kegan Paul, London.

Wright, Philip, 1974, *Old Farm Implements*. David and Charles, Newton Abbot.

Young, Robert, 1923, *Timothy Hackworth and the Locomotive*, reprinted Shildon 'Stockton and Darlington Railway' Jubilee Committee, Shildon 1975.

Index

Places are listed under their countries.

Also from Heart of Albion Press

Forthcoming

Explore BOOKS

The *Explore* series will provide accessible introductions
to folklore and mythology. Some books will provide
'overviews' of quite broad topics, drawing together
current academic research with popular beliefs. Other
books in the series will deal with more specific topics,
but still with the aim of providing a wide-ranging
introduction to the topic.

Titles planned for 2002 and 2003 include:

Explore Folklore
Bob Trubshaw

Explore Mythology
Bob Trubshaw

Explore Fairies
Jeremy Harte

Explore Green Men
Mercia Macdonald

Explore Holy Wells and Springs
Ian Thompson

Explore Folklore

Bob Trubshaw

'A howling success, which plugs a big and obvious gap'
Professor Ronald Hutton

There have been fascinating developments in the study of folklore in the last twenty-or-so years, but few books about British folklore and folk customs reflect these exciting new approaches. As a result there is a huge gap between scholarly approaches to folklore studies and 'popular beliefs' about the character and history of British folklore. *Explore Folklore* is the first book to bridge that gap, and to show how much 'folklore' there is in modern day Britain.

Explore Folklore shows there is much more to folklore than morris dancing and fifty-something folksingers! The rituals of 'what we do on our holidays', funerals, stag nights and 'lingerie parties' are all full of 'unselfconsious' folk customs. Indeed, folklore is something that is integral to all our lives – it is so intrinsic we do not think of it as being 'folklore'.

The implicit ideas underlying folk lore and customs are also explored. There might appear to be little in common between people who touch wood for luck (a 'tradition' invented in the last 200 years) and legends about people who believe they have been abducted and subjected to intimate body examinations by aliens. Yet, in their varying ways, these and other 'folk beliefs' reflect the wide spectrum of belief and disbelief in what is easily dismissed as 'superstition'.

Explore Folklore provides a lively introduction to the study of most genres of British folklore, presenting the more contentious and profound ideas in a readily accessible manner.

ISBN 1 872883 60 5
Perfect bound, demi 8vo (215x138 mm), 200 pages, **£9.95**

Interactive Little-known Leicestershire and Rutland
Text and photographs by Bob Trubshaw.

For seventeen years the author has been researching the 'little-known' aspects of Leicestershire and Rutland. Topics include holy wells, standing stones and mark stones, medieval crosses, and a wide variety of Romanesque and medieval figurative carvings - and a healthy quota of 'miscellaneous' sites.

The information covers 241 parishes and includes no less than 550 'large format' colour photographs.

There are introductory essays, a glossary and plenty of hypertext indexes. ISBN 1 872883 53 2. **£14.95** incl. VAT.

Interactive Gargoyles and Grotesque Carvings of Leicestershire and Rutland
Text and photographs by Bob Trubshaw.

A selection of images from *Interactive Little-known Leicestershire and Rutland* for those particularly interested in Romanesque and medieval figurative carvings. No less than 240 photos - including plenty of Green Men, tongue-pokers and a wide variety of other grotesques. Introductory text, glossary and plenty of hypertext indexes. ISBN 1 872883 57 5. **£9.95** incl. VAT.

Sepulchral Effigies in Leicestershire and Rutland
Text by Max Wade Matthews. Photographs by Bob Trubshaw.

This CD-ROM makes available for the first time details of the wealth of sepulchral effigies in Leicestershire and Rutland - from thirteenth century priests, thorough alabaster knights in armour and their ladies, to the splendours of seventeenth century Classical aggrandisement. There are even a number of twentieth century effigies too.

350 photos depict 141 effigies in 72 churches, all with detailed descriptions and useful hypertext indexes. ISBN 1 872883 54 0. **£14.95** incl. VAT.

Also from Heart of Albion Press

On Sacred Mountains

Martin J. Goodman

'Such narrow, narrow confines we live in. Every so often, one of us primates escapes these dimensions, as Martin Goodman did. All we can do is rattle the bars and look after him as he runs into the hills. We wait for his letters home.' *The Los Angeles Times*

Martin J. Goodman's interest in spiritual phenomena goes deeper than most people - he goes out and tests their ability for personal transformation. After his internationally acclaimed books *I Was Carlos Castaneda* and *In Search of the Divine Mother*, astonishing perspectives on the psychedelic shamanism of the Amazon and the guru/devotee relationship, comes this most powerful and daring of adventures.

What is a sacred mountain? Study them all we like, the only way of knowing them is to measure their effects in our own lives. Starting at Mount Ararat, moving to Ireland, passing through the sacred heights of India and Sri Lanka, Martin was then called to the mountain ranges of the American South West. At the highest point of Texas he received a revelation of great promise for the survival of humanity. His journey is a compelling story of intimate encounters, sexual transformation, astounding landscapes, and raw mountain energy. The writing is of a rare quality that turns each experience into our own.

On Sacred Mountains will appeal to those interested in travel, and adds a deep spiritual experience to the travelogue. *On Sacred Mountains* will also interest the 'spiritual searcher', especially those who expect their guides to do more than write from the comfort of their retreats.

ISBN 1 872883 58 3. Perfect bound, demi 8vo (215x138 mm), 138 + ix pages, **£9.95**

To order books or request our
current catalogue please contact

Heart of Albion Press

2 Cross Hill Close, Wymeswold
Loughborough, LE12 6UJ
phone: 01509 880725
fax: 01509 881715
email: albion@indigogroup.co.uk

or visit our Web site: www.hoap.co.uk